RHONDDA
THROUGH TIME
Alun Seward &
David Swidenbank

AMBERLEY PUBLISHING

First published 2010

Amberley Publishing Plc
Cirencester Road, Chalford,
Stroud, Gloucestershire, GL6 8PE

www.amberley-books.com

Copyright © Alun Seward
& David Swidenbank, 2010

The right of Alun Seward & David Swidenbank
to be identified as the Authors of this work has
been asserted in accordance with the Copyrights,
Designs and Patents Act 1988.

ISBN 978 1 84868 760 8

British Library Cataloguing in Publication Data.

A catalogue record for this book is available from
the British Library.

Typeset in 9.5pt on 12pt Celeste.
Typesetting by Amberley Publishing.
Printed in the UK.

Introduction

This journey which I want to share with you, in prose and picture has been both personal and public, yielding pleasure and pathos in equal measure.

The travels – real, remembered and researched have brought back many memories of my Rhondda childhood and teenage years, encapsulating simple pleasures in austere times, of good friends sharing fun and games, study and hobbies in chapel, school, café and club – including the advent of rock 'n' roll!

Born during the Second World War, I was raised in Treorchy (where the valley's curtain walls are drawn back wider) into a family steeped in Welsh and chapel culture emanating from Gu – my maternal grandfather William Thomas (pictured front row right) – coal-miner, deacon, lay-preacher, and poet. As I grew up however my family increasingly spoke English. I did attain 'O' level Welsh, even tried to emulate Gu by writing in Welsh on 'Ben Bowen', and singing 'Gymanfa Ganu', but I too lost the fluency. It has been impressive to find so many of today's Rhondda children are so capably bi-lingual.

Rhondda in those days seemed to offer a child so much – fresh air, mountain streams, parks and playing fields, even outings! We mostly walked, ran and cycled. Cars in the '50s were still for doctors and a privileged few (I fondly recall pal Jeff's father driving us to Air Shows). Early fun came from reading – books and 'American' comics, twice-weekly cinema at 3 old pence a time, the same for a bag of chips. My paper-round at age eleven topped up pocket money – for that extra 3*d* in the café juke-box, on the threshold of our teens. School sports and R.V. Athletic Club distinguished my youth activity – sprinting, cross-country and tennis badges, a highlight running the 'Queen's Message' for the 1958 Empire Games.

Too soon adulthood beckoned. After enjoyable years at Porth County Grammar, I soon had to travel and live away for college and career. Collieries closed, and with little new industry my father too commuted to construction projects. Marrying a young Porth lady assured me of

an equally industrious partner for an exciting life journey, though outside Rhondda. Then, we managed hard times in a harsh landscape, both shaped by 'King Coal' and its lingering demise. Visiting today, a grandfather now, I have found the spirit, good humour and innate courtesy of my compatriots still remains evident in quantity.

I am indebted to co-author David for the photographic capture of these qualities. Also we acknowledge the courtesy and conversation of all those good people we've met. Rhondda's new schooling, library, youth, and sports facilities all demonstrate a keen, collective awareness of new needs and the efficacy of their provision. I am heartened, proud of this cauldron of intellect and ability that produces so many wonderful 'sons and daughters' of Rhondda.

I hope dear reader that you enjoy this reminder of Rhondda's powerful presence, for we've enjoyed documenting it.

This oft-quoted axiom, clear in Welsh and English, is tellingly true of the South Wales valleys' coal miners –

'Yn mhob gwlad megir glew'
'Every country breeds brave men'

Alun William Seward, 2010

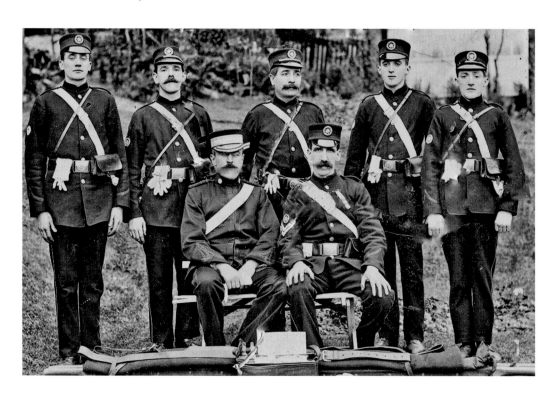

BLAENRHONDDA & BLAENCWM

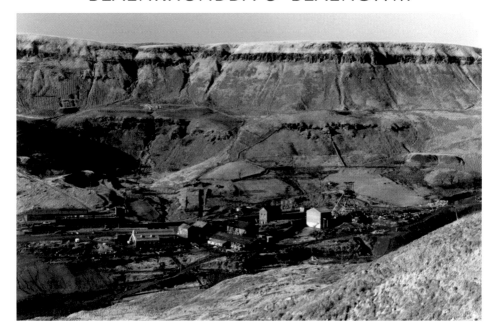

BLAENRHONDDA, Fernhill Colliery, *c.*1980

Situated at the head of Rhondda Fawr flanked by majestic mountains and waterfalls its coal seams still lie some 800 ft. below. The semi-anthracite was abandoned in 1966 after almost 100 years' mining despite ambitious underground linking with Tower Colliery just two years earlier. Today, only scattered scrap-metal reminds of this land's previous use, though its surface shows signs of waste-tips' reclamation. Boggy ground, streams rushing to voids, a lake, all now fresh features in the immediate landscape. Coarse grass and bulrushes try to re-knit this ravelled sleeve of Mother Nature's carboniferous coat.

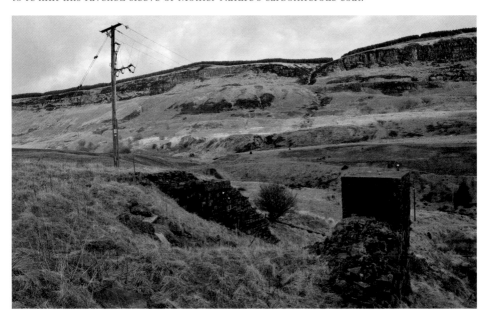

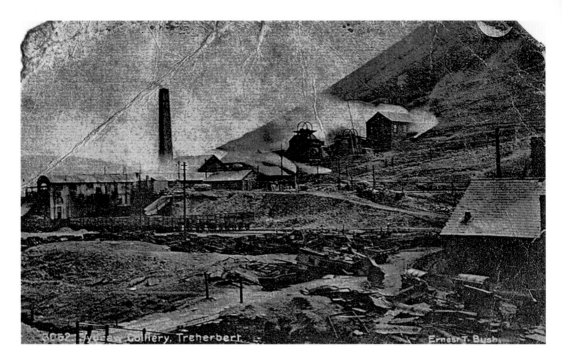

BLAENCWM/TREHERBERT, c. 1910.

Tydraw colliery, on the borders of the two villages was first sunk in 1865, and known locally as the Dunraven after its first owners. After three different ownerships it was nationalised in 1947. When the NCB closed it in 1959 the manpower was still over 350. Today these lower mountain slopes are quiet neighbours, mostly vacant, the ground still dark with spoil waste under a sparse green covering. The land is only notionally fenced off, suitable signage seemingly unsuccessful in fending off trespassers, human or equine.

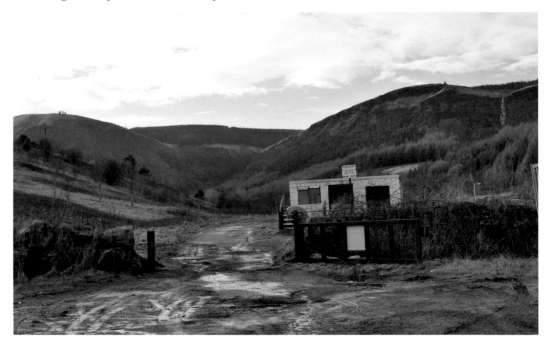

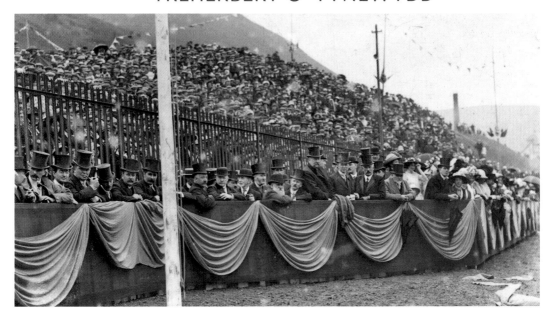

TREHERBERT Railway Station, June 27, 1912

The occasion of the first visit to the Rhondda by a reigning monarch. The royal train bringing King George V and Queen Mary, is eagerly awaited by an enthusiastic crowd – the fencing neatly dividing the 'dignitaries' including RUDC chairman Mr. Thomas Evans, from the rest! Today Treherbert is the last stop up-valley for Arriva trains, so no trip to the top-most Blaenrhondda. Nor can we now experience the thrill of an eight minutes' long steam from Blaencwm through the dark of the Blaengwynfi tunnel on Sunday school trips to Aberavon seaside!

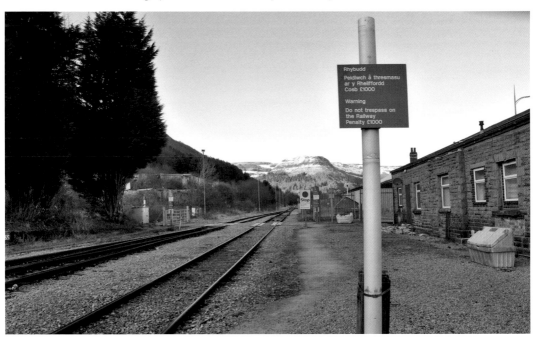

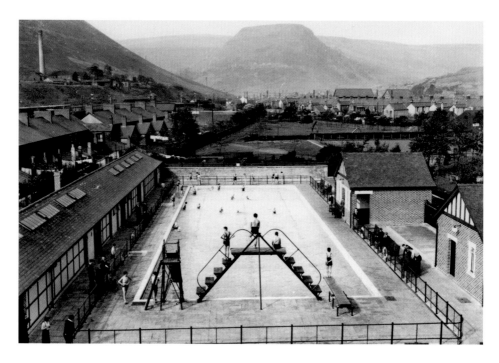

TREHERBERT Swimming Pool, c. 1949

Remembered by many as the open-air baths chaperoned to by a teacher for swimming lessons. A truly popular public amenity, the pool was 8'6" at the deep end, and steps up to a diving board of fearful height at eleven or twelve years old! It is now a covered facility, a complete building neatly sitting over the original perimeter, with car park. Closed by the council's budget cuts, campaigners are seeking public subscriptions to purchase.

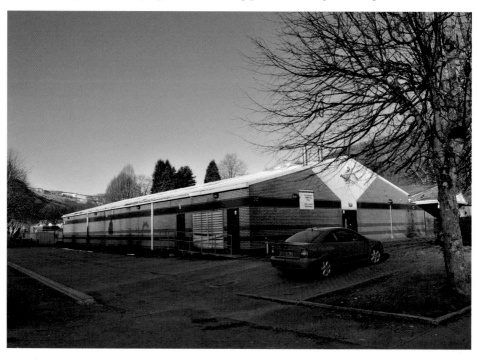

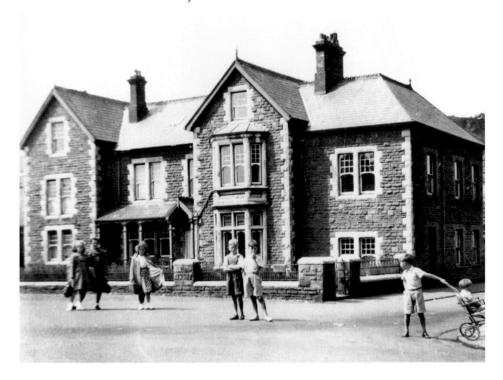

TREORCHY, Dyfodwg Street. *c.* 1954

'Gilnochie', the imposing detached villa-style residence of Dr. Fergus Armstrong – GP and Surgeon, his brother John, and housekeeper 'Rosie'. Dr. Ferguson was significant in the treatment of local problem diseases such as diphtheria and silicosis. Today in contrast, the house and gardens are gone, replaced in 1971 by the contemporary Treorchy Library building since extended to combine the 'ONE4All' services and the later youth section. Quality services include standard and special form publications, audio books, microfiched records, image enhancer, even a wifi 'hot spot'.

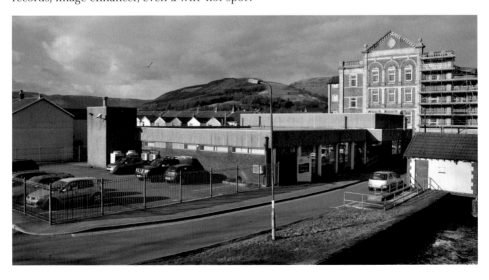

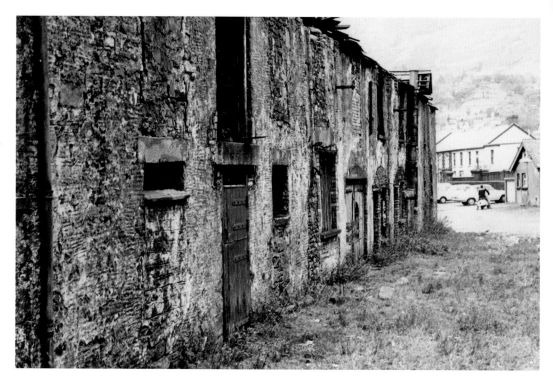

TREORCHY, Dyfodwg. Stables utilised by Ocean Coal Co., _c._ 1967
Shown in the latter stages of decline, these stables offered farrier and rest facilities for coal ponies for the Parc and Dare collieries (which after nationalisation in 1947, were both closed in 1966 by the NCB). Today the redeveloped land provides increased car parking for the combined library and 'ONE4All' public offices. Visitors' WCs though not forgotten are still outside!

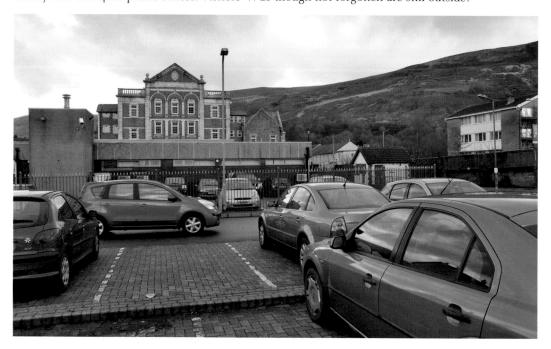

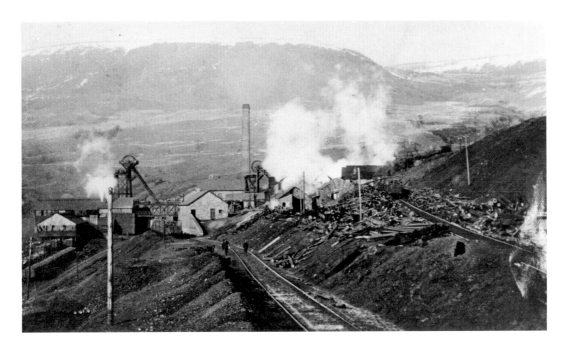

TREORCHY, Abergorky Colliery, c. 1900

Set against the Maerdy mountain where the Ffolch falls give rise to the Orchwy stream, the small pastoral vale was transformed by this colliery first in 1865, more so in 1884 when deep shafts were sunk into the steam coal seams. After various owners it became part of Ocean Coal Co., closing in 1938. Men and women often walked to work including the author's grandfather Mr. William Thomas. When colliery shafts were capped, refuse scarred the site. Now stabilised, and coal tips removed, flora and fauna have returned. Childhood memories remain of hurtling down the small-coal slopes on makeshift sleds.

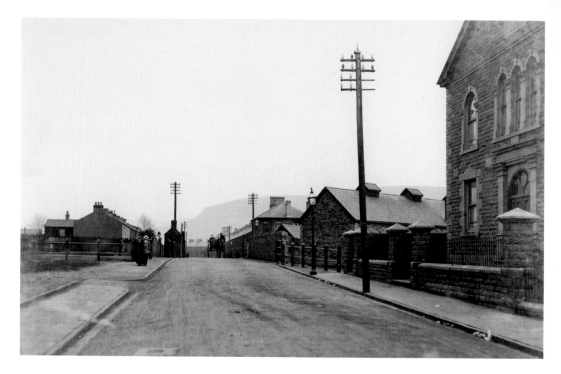

TREORCHY, Ynyswen Road/Bute Street, c. 1900

Looking south east across to Bute Street this gated level crossing, with stone gatekeeper's office, served to control traffic for trains from Abergorky colliery to join Taff Vale lines down-valley to Cardiff and Barry docks. Today, the crossing is redundant. Though not finally removed until the 1950s. The part-culverted Orchwy still flows down and under the road here to join the River Rhondda nearby.

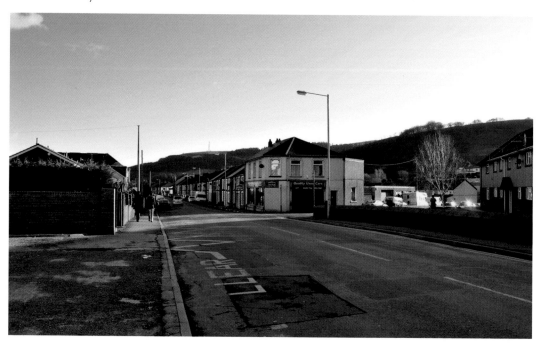

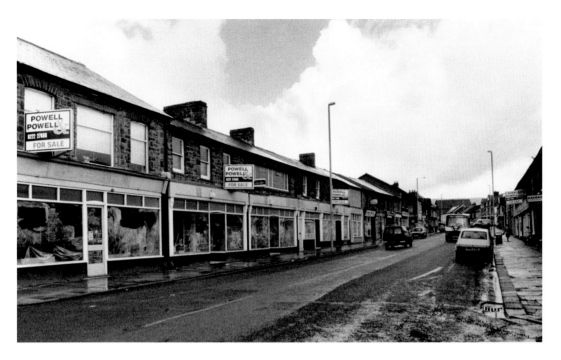

TREORCHY, Bute Street. Co-operative Society shops, 1988
Established early twentieth century and operating under the great CWS supply umbrella, Treorchy Co-op dominated local shopping with departments for grocery, butchery, clothing, a chemist's, also drapery and furniture/electrical. Members received dividend points for each purchase value, redeemable for goods at quarter ends. Great for a boy with a generous aunt!

1988's closure was the end of a retail era. Today we see a range of individual shops; the grocery 'heart' of the original enterprise is now a Spar store.

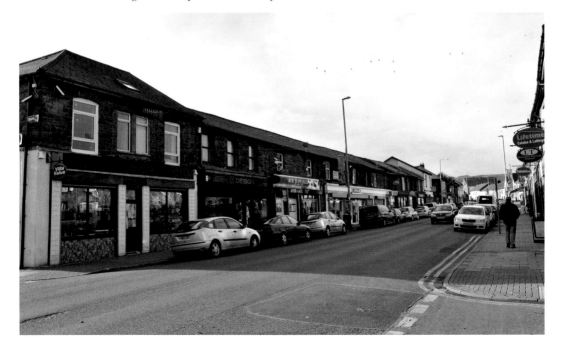

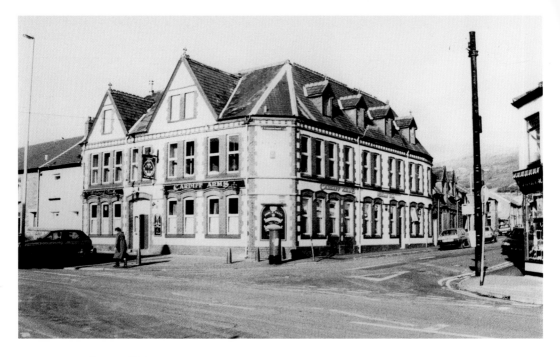

TREORCHY, The Cardiff Arms c. 1990
Still dominating the 'square' from the corner of Cemetery Road, this renowned hostelry is seen after some essential maintenance twenty years ago. The shy figure passing on a sunny day is author's aunt Mrs. E. Jenkins heading home to Ynyswen from the shops. Today, vacant, and now a listed building, it is receiving some fresh attention. There is the prospect of new commercial activity after twenty-six years' service by 'Team D., C., and R.'. In the vibrant 1950s, the legendary landlady is remembered as 'Annie Maude'.

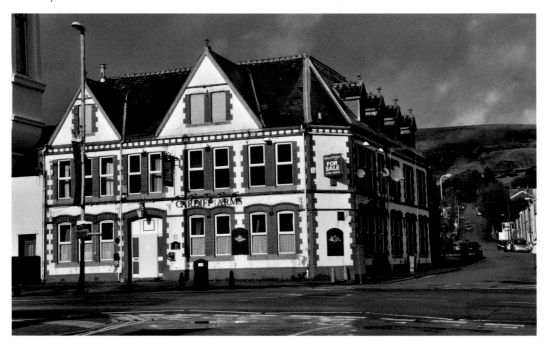

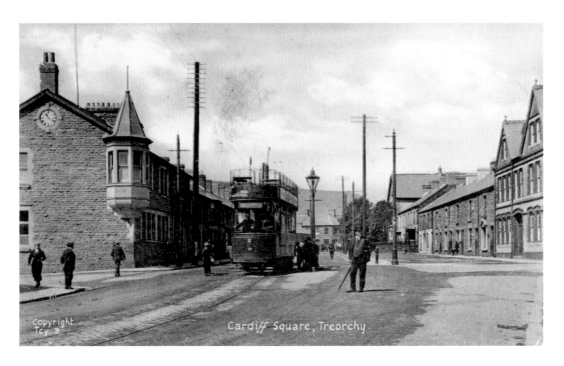

TREORCHY, Cardiff Square, c. 1920

The 'electric' Rhondda Tramway Co. provided competition to Taff Vale railway to provide public transport in the upper Rhondda from 1908. A central lamp-post and care-free strollers are seen close to the central rails of the trams, which replaced the horse-drawn 'omnibuses' of the late nineteenth century. Today's square is altogether busier and better lit, its traffic long necessitating a safe zebra crossing. It still features the opposing buildings of Cardiff Arms Pub and the Conservative Club with its clock and distinctive turreted oriel window.

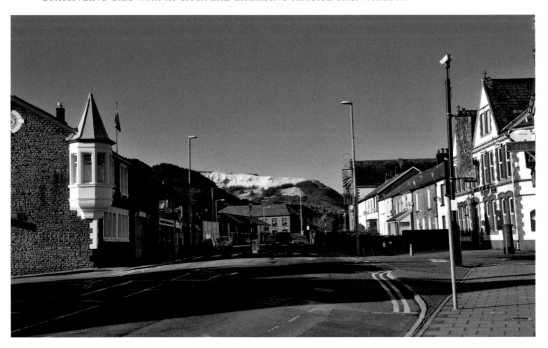

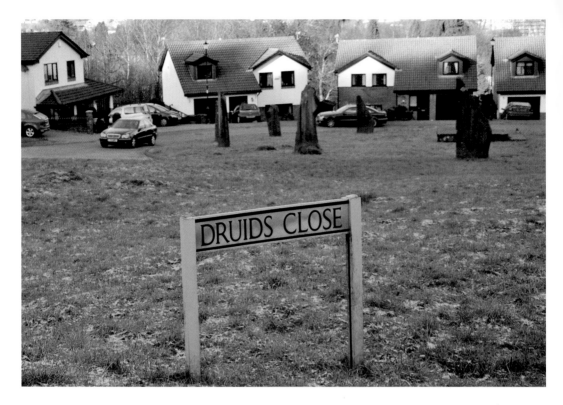

TREORCHY, Maindy. Gorsedd Stones circle
Built by a Rhondda stonemason for the Eisteddfod of 1928, this bardic circle of limestone obelisks was established on the slopes of Maindy benignly overlooking a substantial Treorchy township Today these Druidic sentinels are still *in situ*, but also serve as the front aspect of a semi-circle of modern residences – Druids Close.

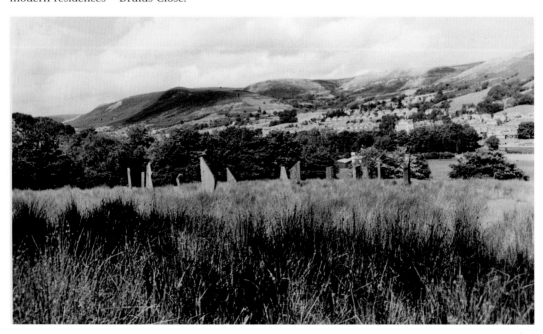

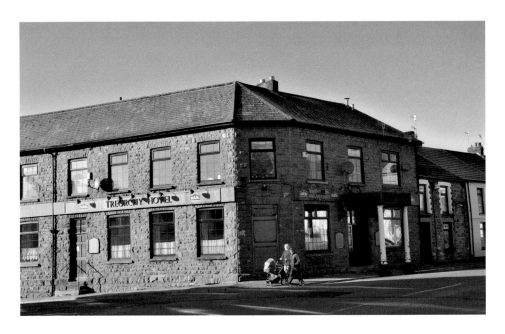

TREORCHY, Bute Street, c. 1900

The Treorchy Hotel was an early respondent to the demand for room, ale and good fayre in the booming early twentieth century. Its frontage, with formal pillared portico opposed the Abergorky Workingmen's Hall which offered competitive distractions of reading, billiards, and later a cinema. Today the hotel is still open for business including cooked meals, and over a century on its dressed stone exterior is unchanged except for new fenestration, and less chimneys.

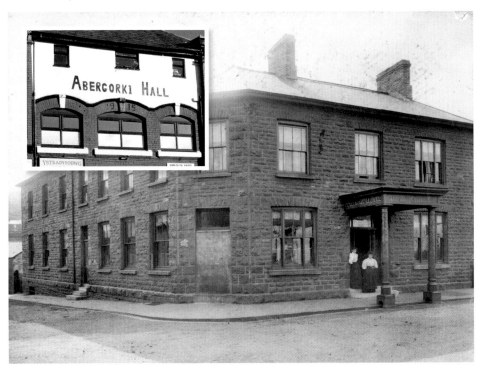

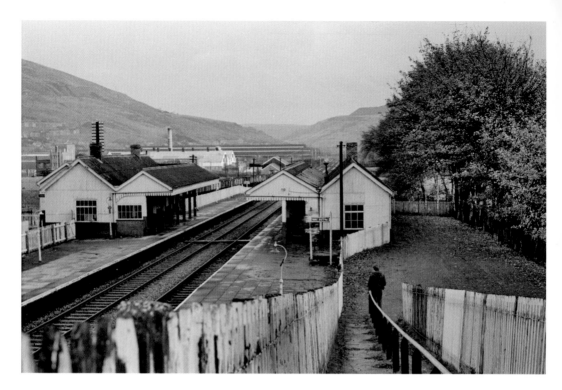

TREORCHY Railway Station 1950s

Treorchy railway station in the 1950s, buildings and wooden fencing painted GWR cream and brown. The waiting and staff rooms saw coal fires in cold weather, and commuters were sheltered to part of the long platforms. The foreground is the steep path from the 'up' platform exit to the road bridge. Today, from the opposite direction we see the absence of station buildings to re-aligned track. This approach originally had a single-storey cinema adjacent to it – the Pavilion, now demolished.

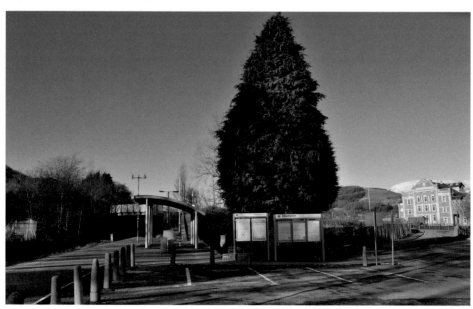

TREORCHY, Bute Street, c. 1953
Boots the Chemists traded from a small shop in these early days of the National Health Service, white-coated staff dispensing innovative prescription, hygiene and health-care remedies. Boots later took over the larger premises of competitors Timothy White & Taylors on Stag Square, and then moved again to their present store in High street, replacing a supermarket. No. 113 Bute Street today offers different treatments for looking better, as a tanning and beauty salon.

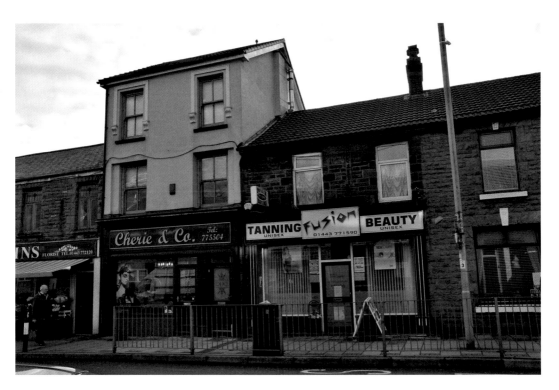

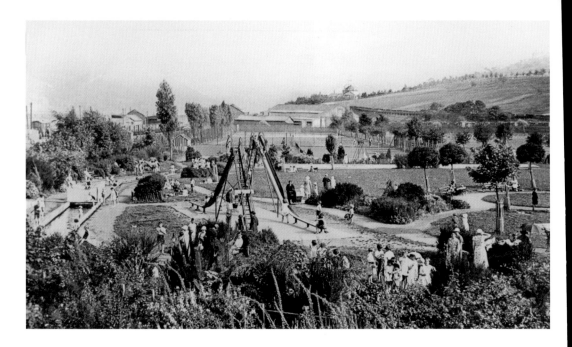

TREORCHY, Ystradfechan, c. 1940

A charming, surprisingly sylvan view of Treorchy Park being enjoyed by children and adults, showing the well-remembered water-way, and slides, climbing frames, and swings that provided endless fun. To the rear are the courts of the tennis club, and far right some playing field area and the cricket pitch. Today the park has lost the 'Italianate' waterway, but gained a paddling pool and children are able to enjoy a range of playing facilities.

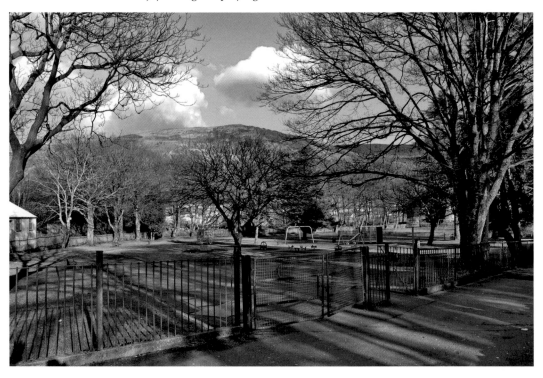

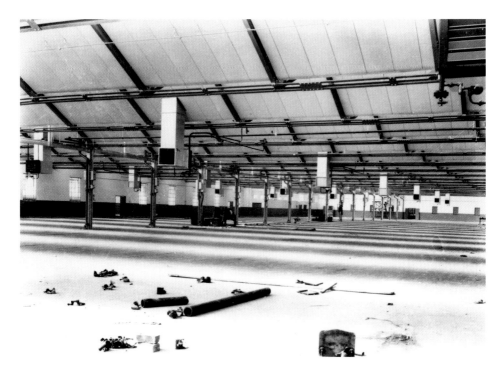

TREORCHY, Ynyswen, c. 1949
Clear floor-space awaits production machines for Alfred Polikoff's new tailoring factory. Welcome post-war employment, within walking distance for local ladies and gents. In 1989 it changed ownership to the notably English firm Burberry. Today the factory's many bays stand grimly silent following the shock closure of the whole factory in 2007, the owners switching manufacture to China despite a brave, magnificently-fought campaign by the workers supported by the whole community, many celebrities, local MP and AM.

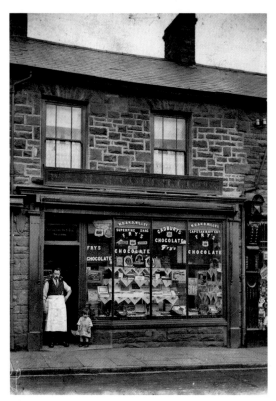

TREORCHY, Bute Street, 1920
The 'Italian' café of Mr. & Mrs. Emanuelli
and young family, living behind and
above the shop. From the 1950s the café
was run for 'Mama' by daughter Angela
and her sister. They re-named the café
over a modern shop-front and installed
one of the first juke-boxes, just in time for
the advent of rock 'n' roll'! Today 'Angie'
has retired, whilst the café is now a shop.
No more Coke/ Pepsi and a hot tune from
precious pocket money in those far-off
pre-teens. The author is seen refreshing
those memories locally.

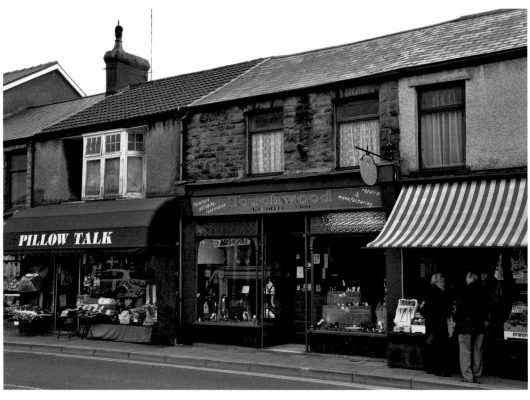

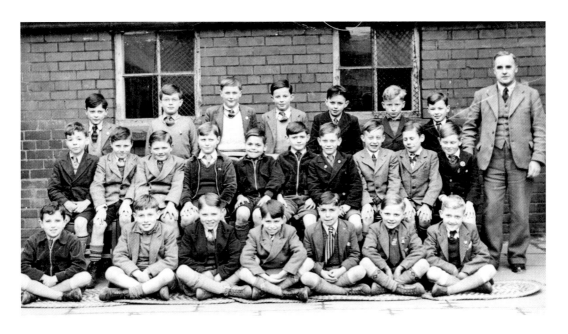

TREORCHY Junior School, c. 1950

What a promising bunch! Standard 2 – author and great classmates (boys), with our revered teacher Mr. Tom Breeze who nurtured us so effectively through to the seminal 11 plus examination. A truly wistful re-visit of the classroom we all shared – almost sixty years on, a pleasure and privilege. Today the school building has a new life as a Youth Centre, equipped with IT, gym equipment and craft facilities such as we could never have imagined then. An inspiring new facility to engage today's local young hopefuls!

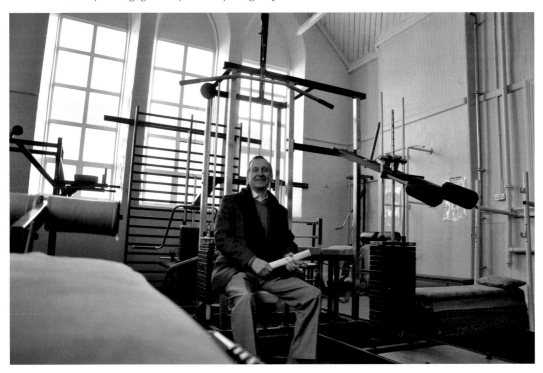

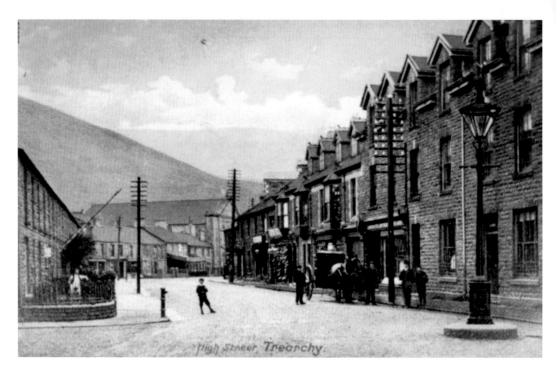

High Street, Treorchy.

TREORCHY, Stag Square, c. 1905

Outside the Stag Hotel, seen on the right, a quiet and leisurely scene of children playing, and people casually chatting. Yet the ferocity of mining machinery cannot have been far away, for the Tynybedw and Tylacoch Collieries were just a half-mile or so in opposite directions. Inside 'The Stag' today the bar in the left-hand lounge seems hardly to have changed. Refreshments are still as welcome, and just as congenially served too!

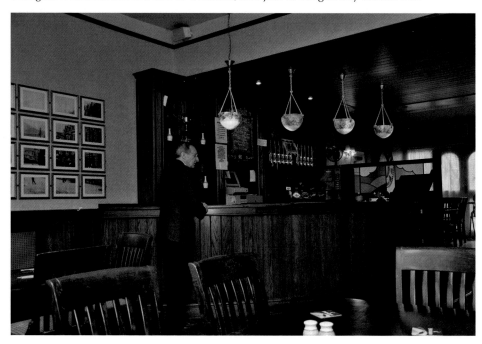

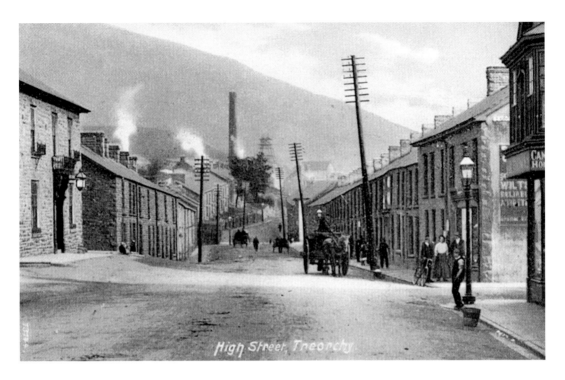

TREORCHY, High Street, c. 1900

Early gas street lamps, leaning telegraph poles and a sloping street. Folk strolling and talking, their transport choice a bicycle or horse-drawn carts. In the picture's background is the Tynybedw Colliery. The Red Cow hotel in left foreground was the formative venue in 1883 for the now world-renowned Treorchy Male Choir. Closed in 1933, little evidence of the colliery or its chimney remains. The road now more level is still flanked by the same terraced houses and the Red Cow has survived into a third century.

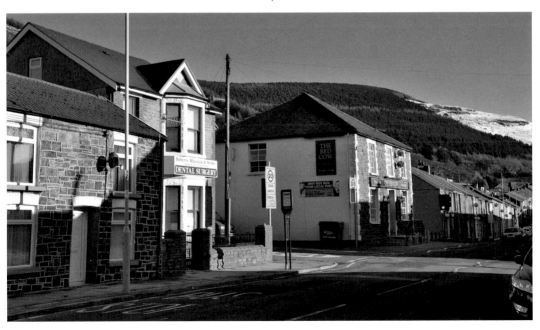

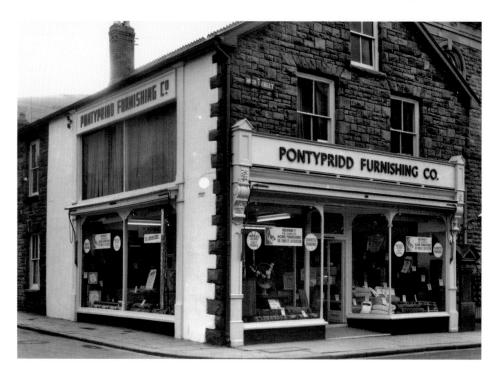

TREORCHY, corner of Glyncoli Road, *c.* 1954

This furniture shop was very popular, especially after post-war austerity. Housewives welcomed new choices of colours and modern fabrics for a new look at home. The large first floor side window facilitated display and alternative loading access for large items. Today that side elevation has changed, and a new business trades in home accessories. The mighty next-door presence of Noddfa chapel has gone too, opening the skyline to High Street and Horeb Street.

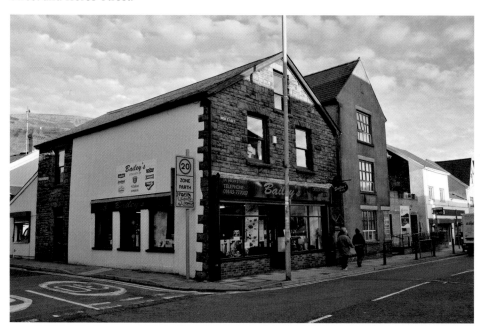

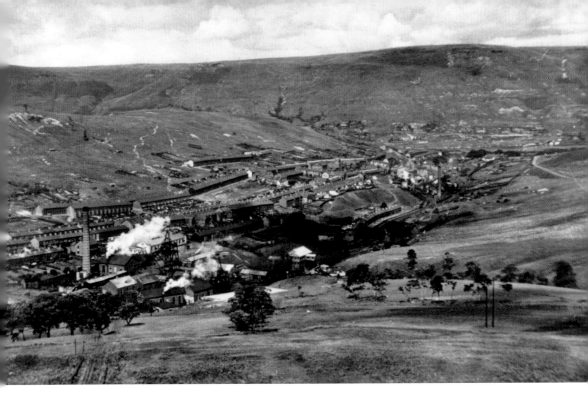

CWMPARC, Parc Colliery, *c.* 1910
Two tall colliery chimneys are seen
dominating this 'cul-de-sac' village. In
turn they are dwarfed by the majestic
back-drop of Bwlch-y-Clawdd. From
1864, black was soon the colour, and
noise and smoke clung to the previously
pastoral slopes. With sister pit, the Dare,
a peak manpower of 2,200 workers
poured into work here, the tiny village
straining to cope. Cwmparc's surrounds
are green again today – both pits closed
in 1966. A lone miner from those days
views the vacant land and remembers
coal and comradeship, dust and danger.
The silence is deafening.

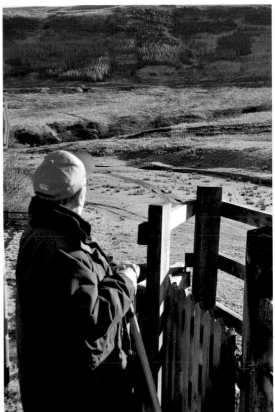

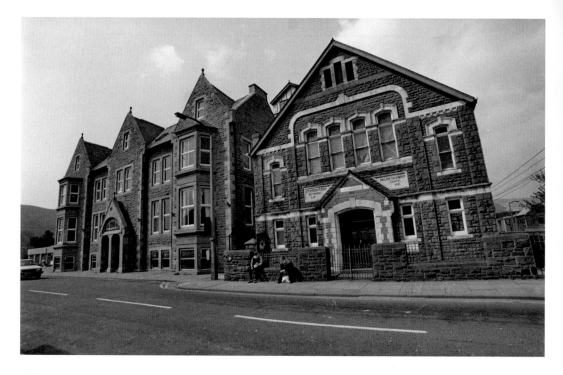

TREORCHY, Station Road, *c.* 1990

English Calvinistic Methodist Chapel, a presence since the early twentieth century was jammed between the original Parc and Dare Hall and River Rhondda as it passes under the road bridge to Stag Square. It is distinguished by being one of the few English-service chapels, but today, sadly demolished – just one of over forty Rhondda Fawr chapels closed, removed, or de-consecrated for alternative use (from martial arts to warehouses). The open area now allows easier maintenance of P. & D.'s pine-end walls.

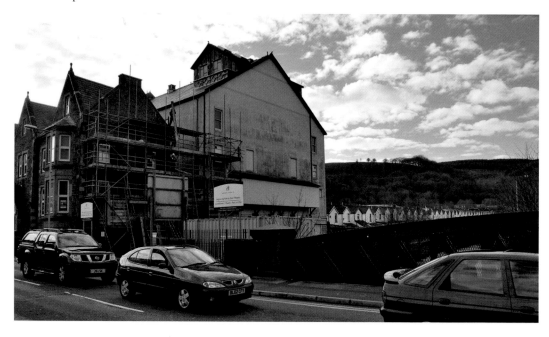

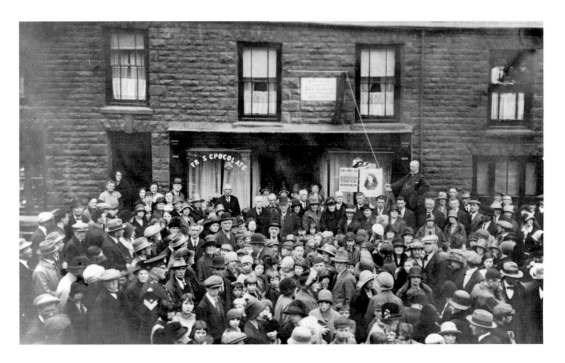

TREORCHY, High Street, c. 1920

The crowded unveiling of a plaque at the birthplace of controversial Welsh poet Ben Bowen. Coal-miner, university student, and precocious literary talent, he achieved much in a short life, dying before his twenty-fifth birthday. He won eisteddfod Bardic chairs in 1896 aged eighteen, and 1897. Well-versed in Welsh and English literature, his interests also encompassed contemporary scientific thought bringing him into conflict with orthodox theologians, and excommunication by his own chapel – Moriah, Pentre. The plaque still graces the house front today, the ground floor is now residential after many years as a shop for Gerry the barber.

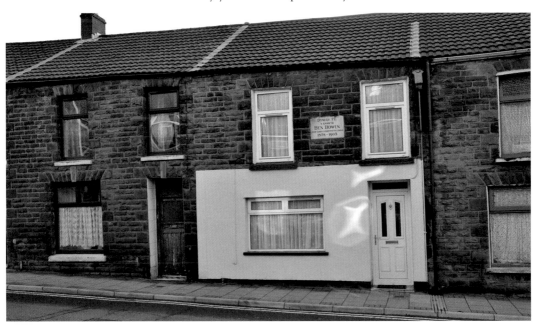

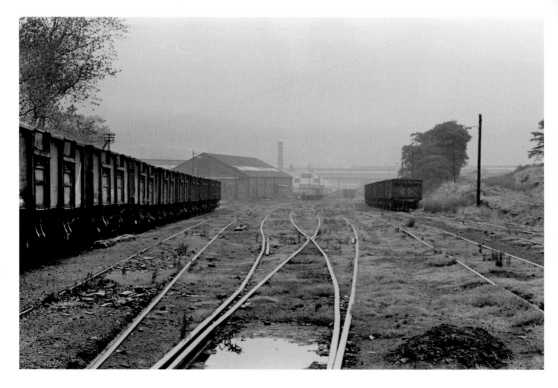

TREORCHY, Cwmparc Road, *c.* 1969 Ocean Coal Co. rail sidings
Seen after the Parc and Dare collieries' closures, the rusting rails and standing stock sit amidst silt and spoil heaps – sad reminders of more active days. Today, the redeveloped site accommodates Ysbyty George Thomas, named in honour of Rhondda's parliamentary 'Mr. Speaker' – the Viscount Tonypandy. Cwm Taf NHS Trust's hospital provides 100 beds for the care of mainly elderly patients, also some GP medical beds.

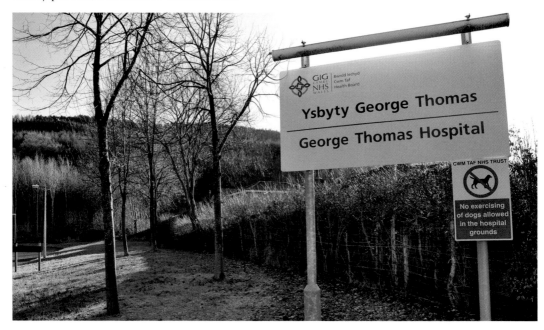

PENTRE, TON-PENTRE & GELLI

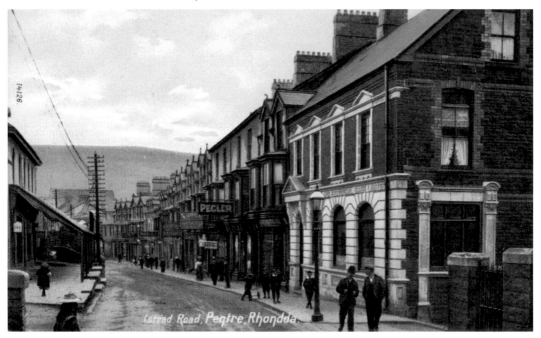

PENTRE, Ystrad Road, *c.* 1910

Though poorly surfaced, this section of Ystrad Road shows a variety of shops, and low and high houses fronting both pavements. Traders' names include Pegler's grocer's, and in the right foreground the imposing bank would soon be re-named Barclays. Today, the bank is a nursery, the adjacent pillared gateway no longer opens to a chapel. Shops have largely disappeared here – gone are the grocer's, Hodges menswear, and the popular Willis-owned Grand cinema, housing clearly residual.

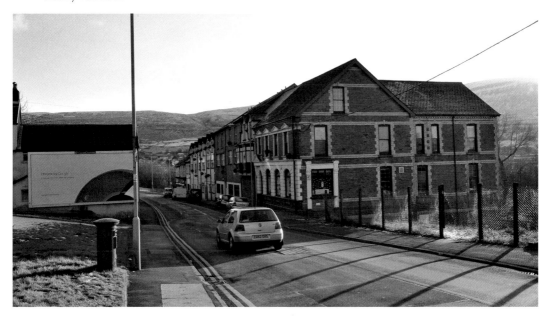

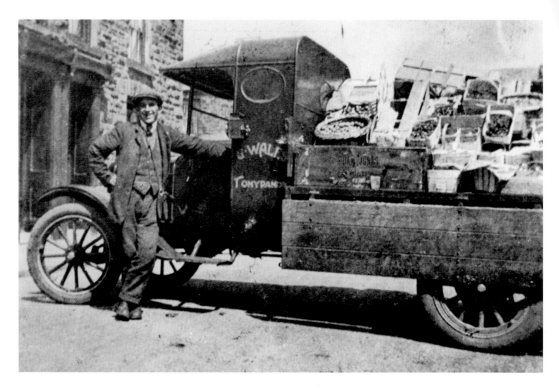

TON PENTRE, Bailey Street, *c.* 1930

Mr. Gomer Wales, resident of No.22, and local Fruit Merchant, on his sales rounds; seen proudly standing with his load of fruit and veg – the first Ford 'Model T' lorry in the Rhondda which he garaged at his base in Tonypandy. Today's Bailey Street terrace with some new roofs and modern double-glazed windows still includes No. 22, with Bodringallt School still faithfully serving the locality's children.

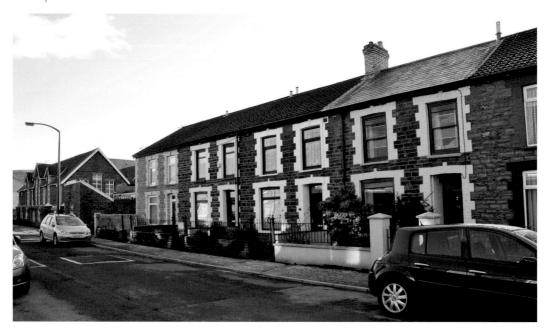

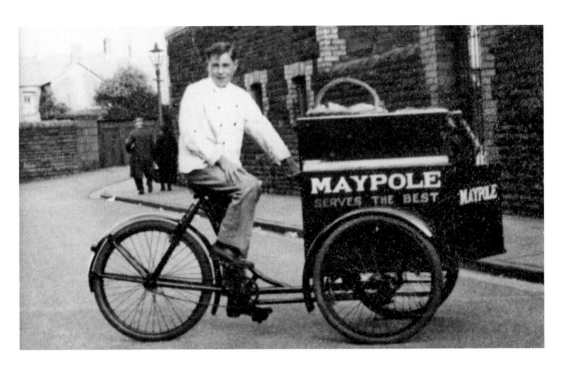

GELLI, outside school, Dorothy Street, c. 1930

Home delivery by pedal-power. Maypole was a popular grocery chain. Its clever slogan seems to extol the virtues of its wares and its customers too! Today, replacing the school is an attractive modern residential complex contrasting with the strong stone terraced houses, now over 100 years old. The bridge at the street bottom is now pedestrian only.

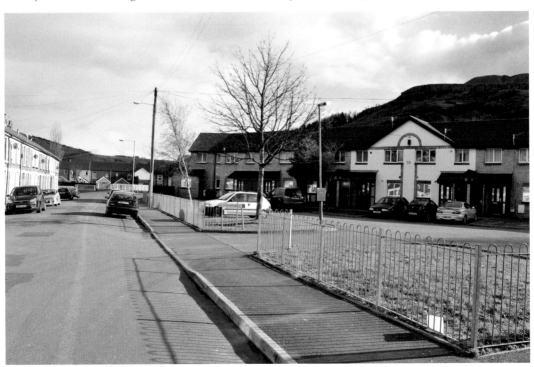

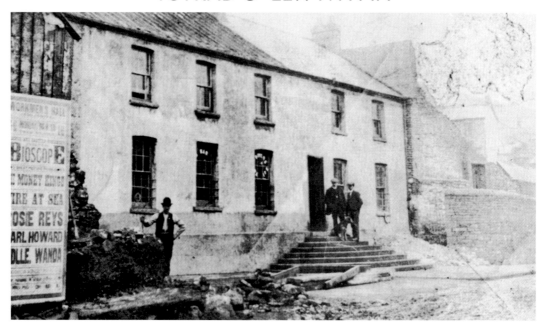

YSTRAD, at foot of Penrhys Mountain. Star Gellidawel Hotel, c. 1913
From its original building, said to be the oldest hostelry in the two valleys. Innovatively the 'new' Star was built up around the old as it was being demolished – so that the licence should not be lost. Advertising revenue wasn't lost either as we see an adjacent bill-board proclaiming the virtues of 'Bioscope' cinema! Today it still dominates the route over Penrhys (always by single-decker buses only) from Fawr to Fach, its historic star still shines down.

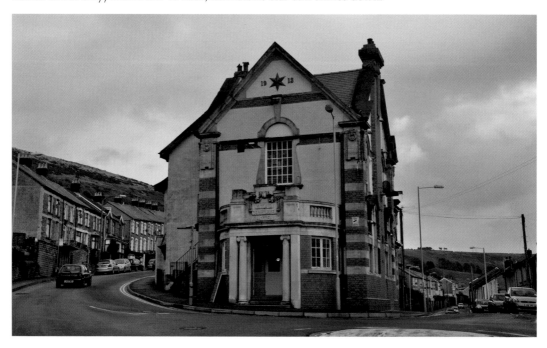

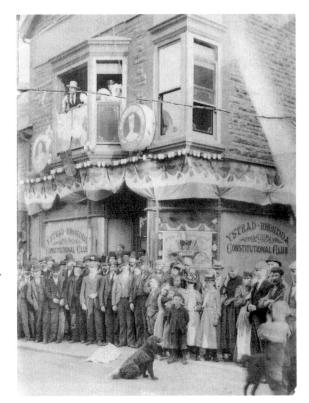

YSTRAD Rhondda Constitutional Club, c. 1910

A crowd of ladies and gents of the day plus a patient pet labrador celebrating in front of the club decorated and featuring pictures of King George V and Queen Mary. One century later and the club no longer reside here. The ground floor of the building, which appears for sale, bears the fascia of a Ladbrokes betting office.

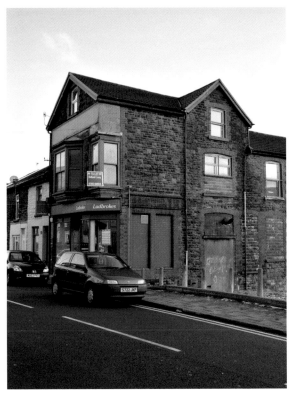

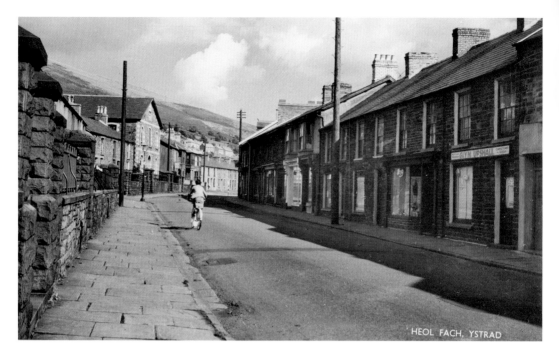

YSTRAD, Heol Fach, William Street, c. 1960
Just fifty years ago but showing a main street without a single car, indeed no one about save a solitary cyclist – maybe a Sunday morning and some worshippers may be in Bethel chapel seen left background. Today the chapel is a youth leisure facility, and the road-sides accommodate today's ubiquitous motor car.

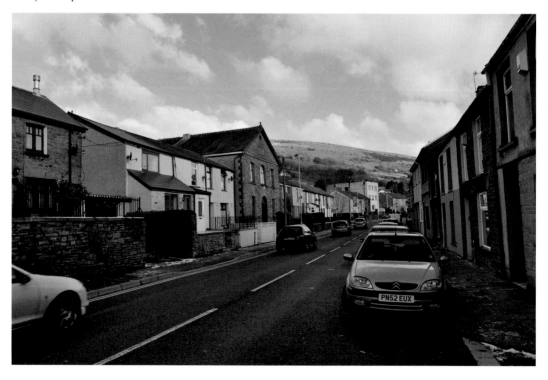

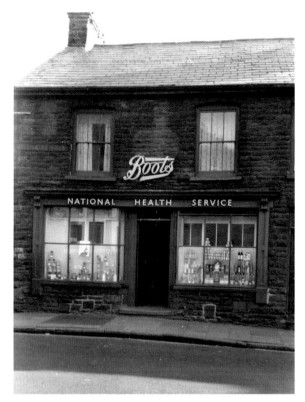

YSTRAD, corner Gelligaled Road/ Mill Streeet, *c.* 1953
The windows of this branch of the ubiquitous Nottingham Chemists company unusually proclaims the NHS. on its fascia, at this time still in its infancy and seemingly worthy of promotion. Today this end-terrace premises is still a chemist (or 'pharmacy') and, as a sign of the times a CCTV camera secures its perimeter whilst metal shutters guard its windows when closed.

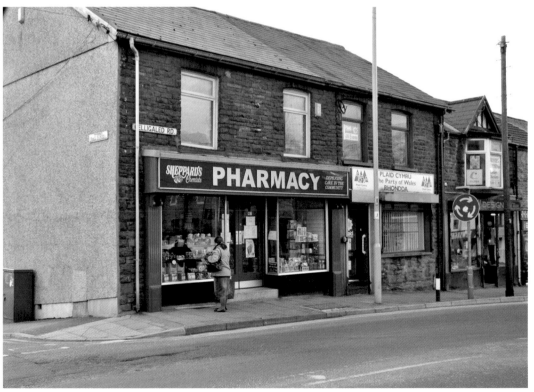

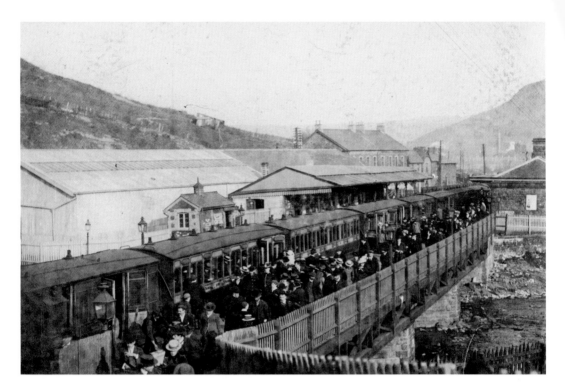

YSTRAD Railway station, April 1902

Shows a 5 p.m. 'home' train. A throng of passengers leave a crowded platform, the waiting and staff rooms in the background. A busy time for a notable station – it was from here in 1853 that the first load of upper-Rhondda coal was to leave by rail for the docks. Today's picture could not be more different – no station buildings, no staff, indeed few passengers about, but a provision for 'Park and Ride'. Adjacent former rail land is now the site of a substantial modern nursing home.

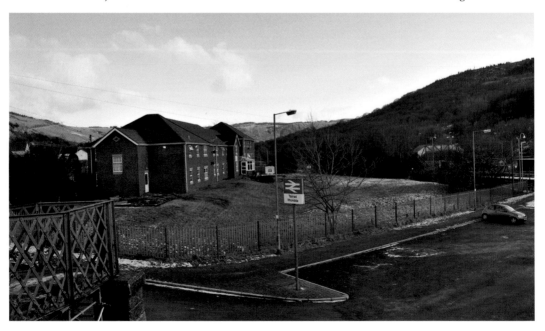

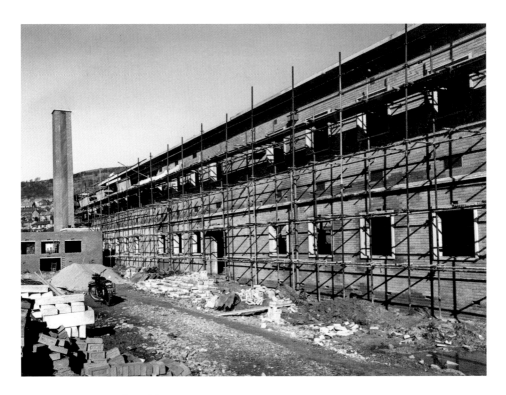

LLWYNYPIA, Pontrhondda, c. 1955

Rhondda College for Further Education under construction – to accelerate the provision of quality higher education, an institute which was to foster relations with local industry and employers. Today this campus has expanded massively in structure and facilities demonstrating a widely diverse prospectus under the auspices of Coleg Morgannwg which has four more Rhondda colleges in its portfolio.

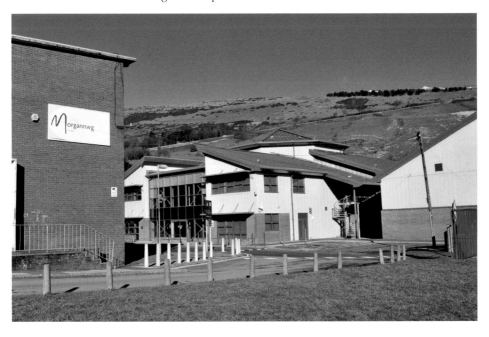

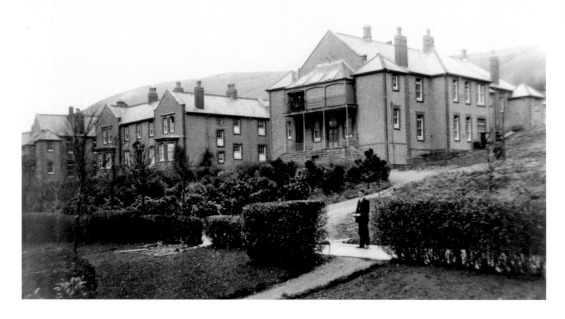

LLWYNYPIA, The Hospital, *c.* 1930

The early buildings of this important Rhondda hospital seem to cling to the severe southern slopes of Penrhys. A new out-patients department was opened in 1935 by Medical Superintendent, Mr. Melbourne Thomas FRCS Today, re-furbished wards are joined by additional buildings. New departments meet the changed requirements of medicine and treatment, and car parks the changed needs of staff and more affluent patients. Below, a cleared factories site now presents a comprehensive new medical facility of the twenty-first century Rhondda hospital service.

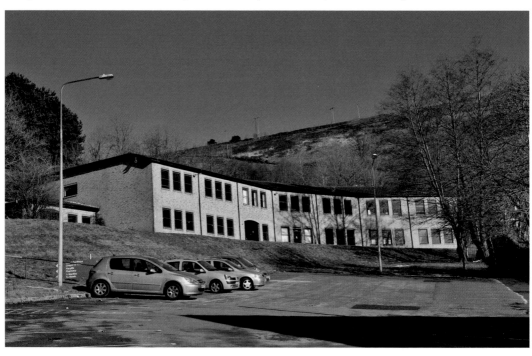

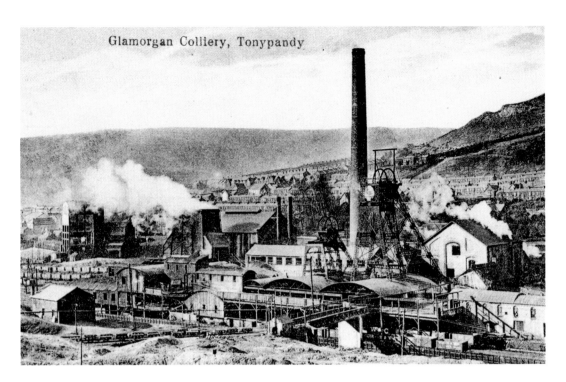

Glamorgan Colliery, Tonypandy

LLWYNYPIA, Glamorgan Colliery, *c.* 1920 (also known as the 'Scotch' colliery after philanthropic Scottish owner Archibald Hood)
From small beginnings in 1861, this was now a substantial complex with large sheds, multiple chimneys, and a surprisingly elegant power house. From 1918, a By-products Plant produced bricks to line shafts during sinking, and build the surface structures. Production ceased in 1932. Today no colliery superstructure survives, except for the Power-house, now a listed building. New commerce now draws the crowds, for behind a bronze statuary tribute to miners past the familiar names of Asda and McDonald's now provide the jobs.

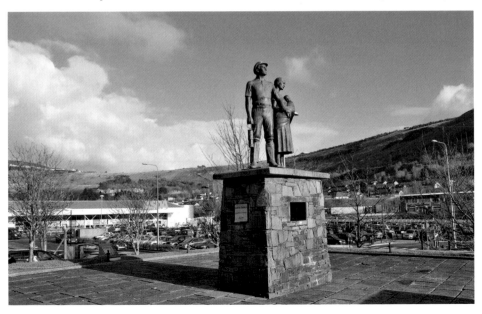

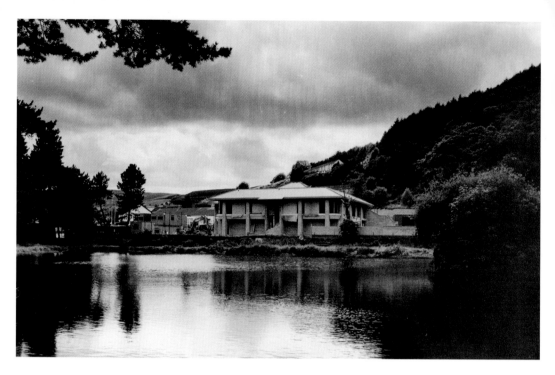

Magistrates' Court

The new Magistrates' Court facility for Rhondda is shown *c.* 2003, during construction, as viewed from the lake in the neighbouring Glyn Cornel grounds. Today we see a well-executed building, – the completed design achieving a modern yet classical architectural statement commensurate with its public building status.

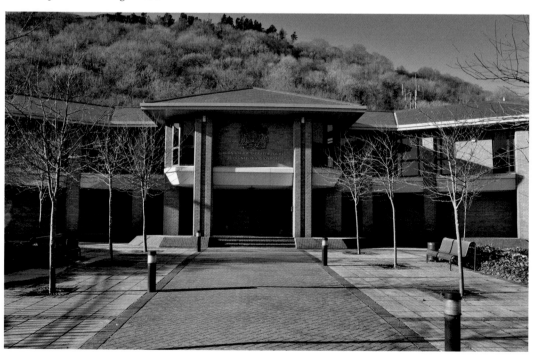

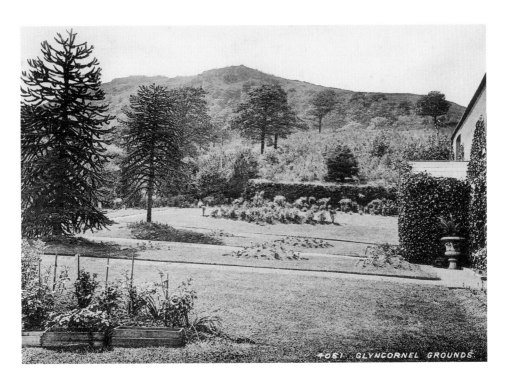

LLWYNYPIA, Grounds of Glyncornel House, c. 1905

Built in the early 1900s by Cambrian Coal Co. to house their senior executives – notably Sir Leonard Llewellyn. Rhondda UDC took over this spacious residence and estate in 1939, using it for evacuee childrenfrom the Second World War, then until 1959 as a maternity home, and geriatric hospital. Today this refurbished property is the home of Rhondda-Cynon-Taff's outdoor education team catering for adult and corporate training, and youth courses. Its lake is apparently still stocked for fly-fishing, and archery is still practiced, continuing the 1960s legacy of the Pentref Bowmen.

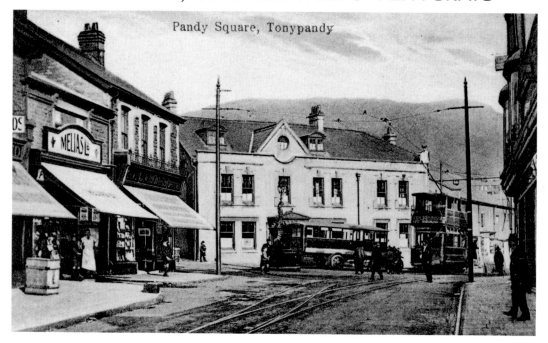

Pandy Square, Tonypandy

TONYPANDY Square, c. 1920.
In front of the Pandy Hotel, central to the busy square is the 'Lady with the Lamp'. A prominent period icon, this statue and fountain was erected in 1909 with funds left over from the public subscription for the memorial statue of philanthropic mine-owner and Scotsman, Archibald Hood erected nearby. Today's square is without the 'Lady' – removed in 1968 following a traffic accident.

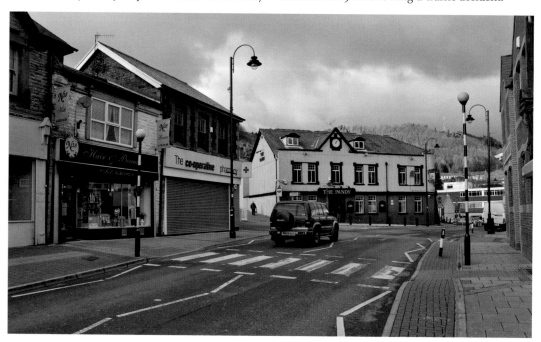

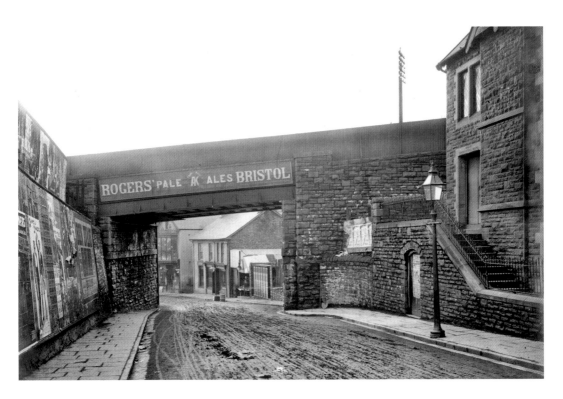

TONYPANDY, De Winton Street, c. 1900

This railway bridge first carried the Pwllyrhebog line over De Winton Street up to Clydach Vale. In 1910, most of De Winton Street's shopkeepers suffered smashed windows and looting during the infamous Tonypandy riots. Today's modern bridge no longer carries advertising for Bristolian-brewed ales, and our view is from a cleared area, now a modern 'Pay & Display' car park.

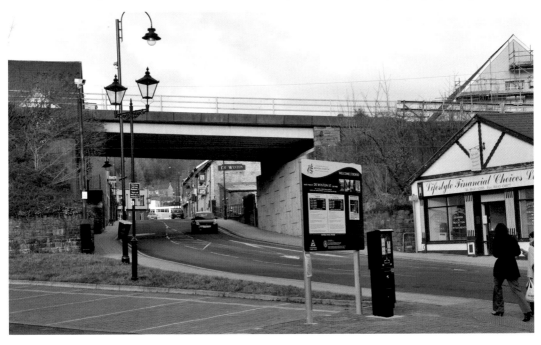

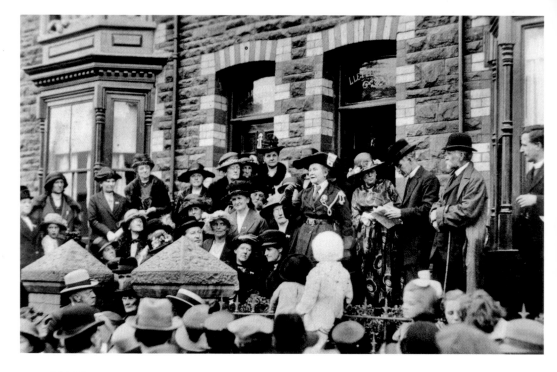

TONYPANDY, Kenry Street, June 1922

Mrs. M. Griffiths, JP opening this residence as a remand home for women and girls who were considered 'in distress', and named 'Lletty Cranogwen' after Sarah Jane Rees of Cranogwen (1839-1916), a remarkable sea-captain's daughter who taught navigation and mathematics in Cardiganshire, Liverpool, and London. In 1859's religious revival she became a Band of Hope leader and Sunday-school teacher. Also a writer and poet, she was a founding member in 1901 of Undeb Dirwestol Merched De Cymru (The South Wales Women's Temperance Union). Today the property is a spacious family home.

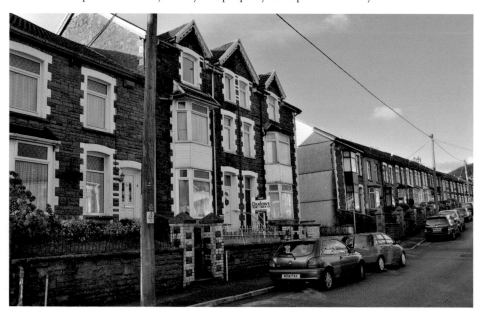

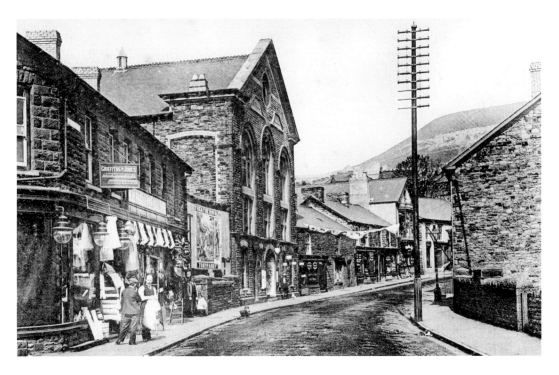

TONYPANDY, De Winton Street, c. 1905

This varied terrace of shops and houses features the ornate chapel-like building first known as Town Hall which became the Theatre Royal – on whose stage so stories go Mr. Charlie Chaplin once appeared, and a live elephant! Re-modelled in 1912, it became the Royal Cinema operated by Messrs. S. Duckworth and W. E. Willis until closing in 1959. Today the terrace's shops are shuttered, whilst the 'Theatre Royal' is now an arcade of varied retail units which initially included a snooker hall.

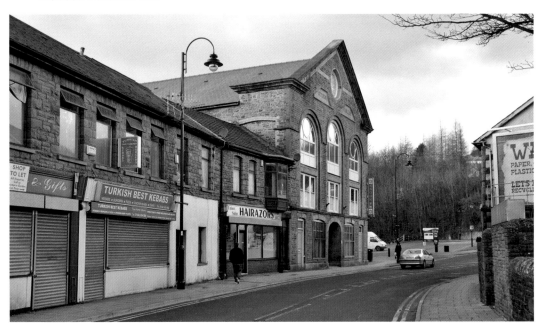

TONYPANDY, former Central Methodist Hall site, *c.* 1986
A red Rhondda bus stops at the lights alongside the redevelopment of the former site of the largest, most iconic Rhondda chapel, for a new Gateway supermarket, and adjacent commercial shopping parade, with rear on-site parking, rejuvenating the lower high street. Today, the store operates under Co-operative ownership, and this development sits outside a pedestrianised Dunraven Street shopping zone.

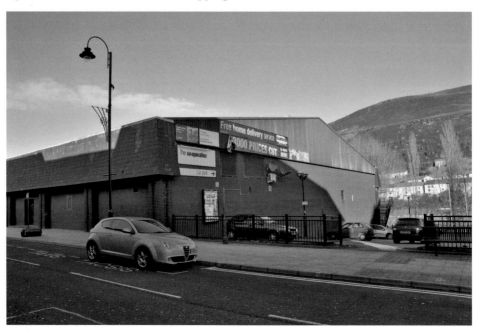

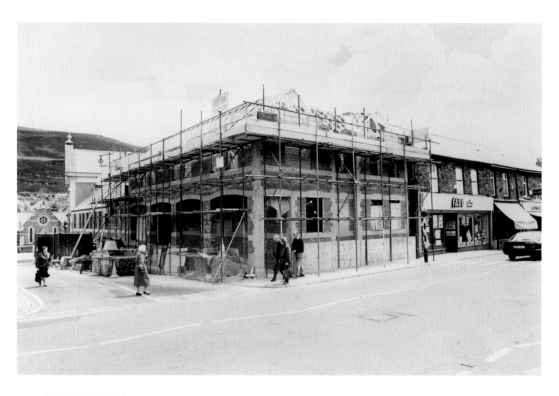

TONYPANDY Square, c. 1994
Formerly a Tonypandy Cooperative grocery shop, a new building rises on this prominent corner site, to open as St. Andrews Surgery (St. Andrews Church is seen in the background). The monolithic brick building creates a dominant new presence here, and incorporates a spacious doctors' surgery and ancillary medical services.

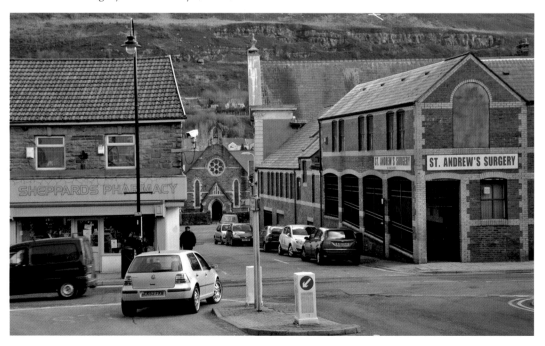

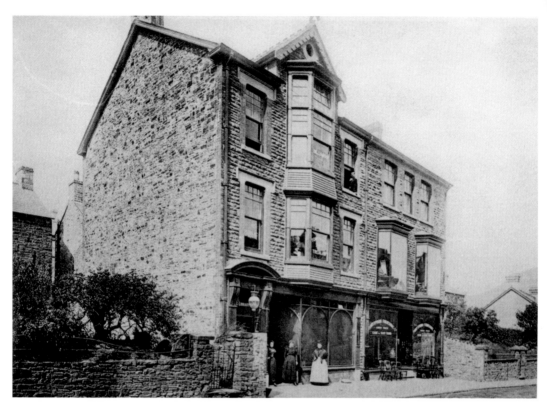

TONYPANDY, De Winton Street, c. 1905
Oriel bays and a towering gable distinguished this building, which interestingly combined commercial use with living and other accommodation to its three floors. A by-product of this entrepreneurial initiative was the first Tonypandy and Trealaw Library premises to its first floor. Today this building now houses the public Library, which was formerly the Caeslem Baptist Chapel, built 1908.

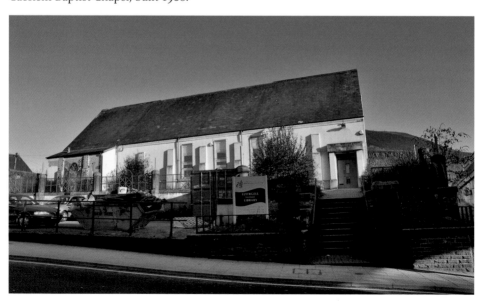

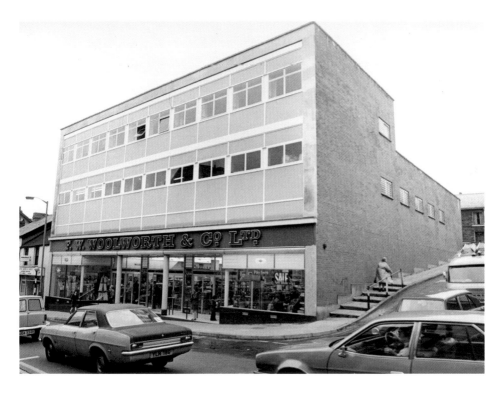

TONYPANDY, De Winton Street, 1980s
The spacious Woolworth's store occupied a 1980s building developed on the site of an old cinema. For some time from the 1950s the only Woolworth's shops were at nearby Penygraig, and Porth. Sadly today the store lies vacant, and its windows about to be shuttered dark, following the failure of this once mighty and iconic American-founded retailer.

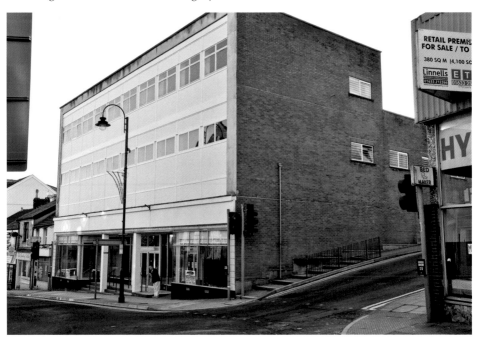

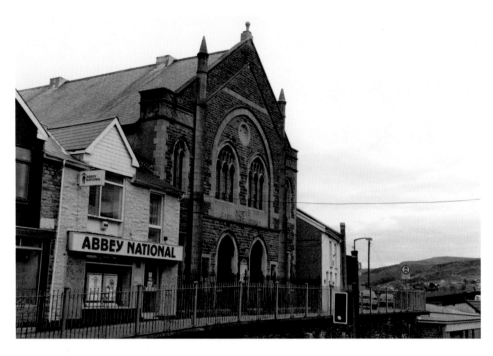

TONYPANDY, Dunraven Terrace, c. 1995

The imposing early twentieth century frontage of Moriah Chapel (Capel y Bedyddwyr) sits on the higher terrace, in company with more commercial 'citadels', and overlooks the main street's many distractions. Today, after conversion to Islam in 2008 – restaurateur and head chef Mr. Islam that is, the former chapel is now an innovative restaurant premises, 'The Prince of Bengal' presenting Indian and Bangladeshi cuisine. Next door's Abbey National is now the Spanish-owned 'Santander' Bank.

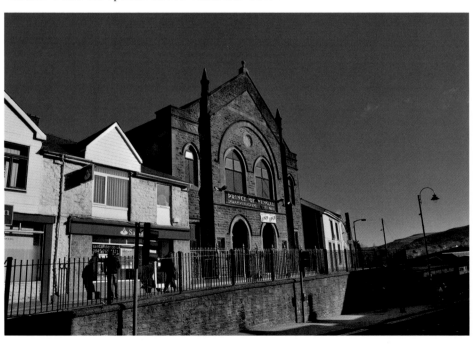

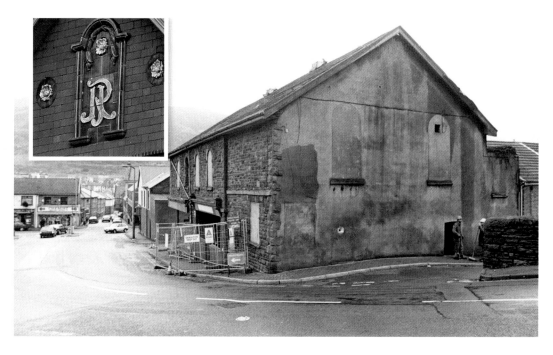

TONYPANDY, upper Pandy Square, 1996
Formerly 'Bethania Welsh Calvinistic Chapel', a building which contributed its tall presence to the upper square, its use prior to its current demolition fate, was as a popular Billiard Hall. Today, sadly, the land lies cleared and fallow, no new enterprise yet exploiting the site.

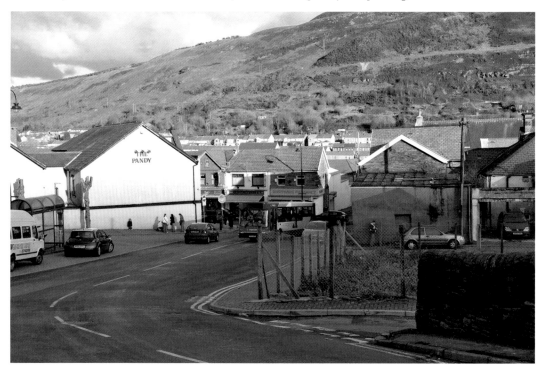

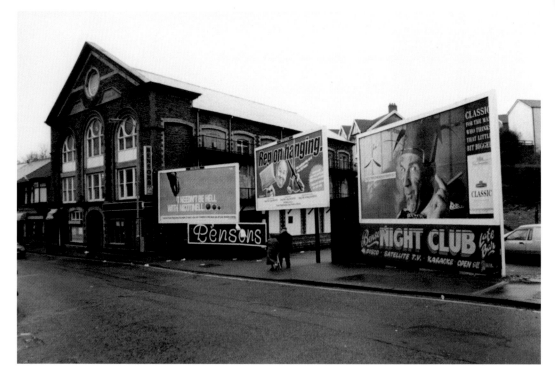

TONYPANDY, De Winton Street, *c.* 1992

First called Town Hall, then Theatre Royal, and afterward the Royal Cinema – this current incarnation is an interesting mix of bazaar-like arcade, and a snooker club. Entertainment again edges into focus with a billboard advert for 'Classic' cigars featuring Russ Abbott cheekily taking off South Wales' comic legend Tommy Cooper, complete with trademark fez! Today, no billboards (certainly no tobacco ads) adjoin the building – instead there is an entrance to a pay & display car park, handy for arcade browsing.

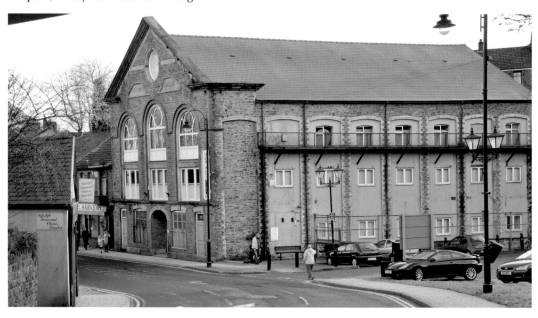

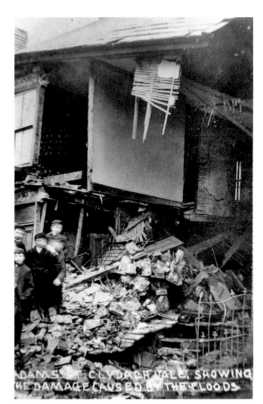

CLYDACH VALE, Adam Street Floods, 1910
A sad example of the domestic devastation to some of this street's houses when a blocked culvert burst and released a torrent of water down the steep hillside to cleave the cottages apart, scattering possessions and endangering life and limb. Today the proud terrace's stonework stands restored, interiors long refurbished, and the road supports modern traffic.

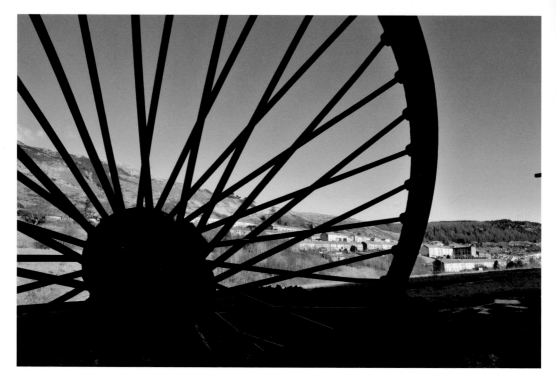

CLYDACH VALE, Cambrian Colliery, *c.* 1900

Opened in 1872, it soon became three pits together. Striking the '6 ft. seam' at 1200ft. depth, output soared and manpower by 1910 topped 4,000 men. However progress extolled two bitter sacrifices, with the explosions of 1905 and 1965 which each coincidentally claimed thirty-one lives. Under NCB ownership the colliery closed in 1966. Today, rusting away on a soil covering now green again, this wheel is a poignant reminder of days of hard labour far below, and jobs lost as oil became the new 'black gold'.

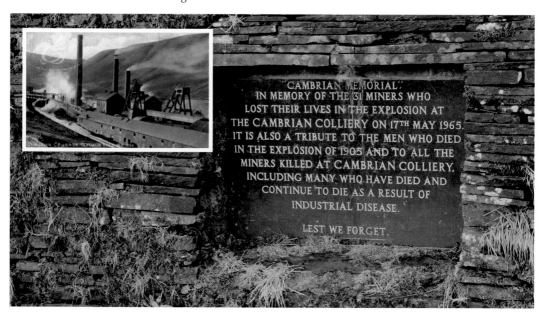

'CAMBRIAN MEMORIAL'
IN MEMORY OF THE 31 MINERS WHO
LOST THEIR LIVES IN THE EXPLOSION AT
THE CAMBRIAN COLLIERY ON 17TH MAY 1965.
IT IS ALSO A TRIBUTE TO THE MEN WHO DIED
IN THE EXPLOSION OF 1905 AND TO ALL THE
MINERS KILLED AT CAMBRIAN COLLIERY.
INCLUDING MANY WHO HAVE DIED AND
CONTINUE TO DIE AS A RESULT OF
INDUSTRIAL DISEASE.

LEST WE FORGET.

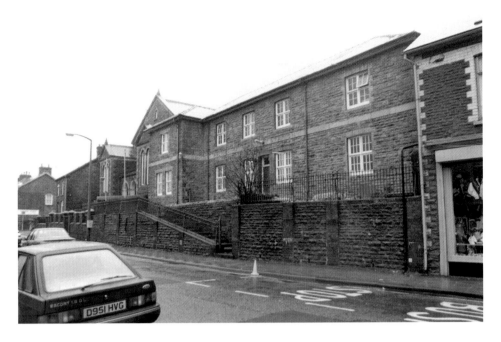

TONYPANDY, De Winton Street, *c.* 1992

Tonypandy Police Station built in 1896, and scene of frenetic activity in the 1910 'riots', was by 1926 up to a complement of three sergeants and ten constables to police a heavily-populated and growing area. Its dressed stone elevations are graced with modern replica-styled double glazing amongst its more obvious up-dates. The road outside sympathetically extols us in large letters to 'STOP'. In the twenty-first century the building seems the same, but without its courtroom. Today's force can mobilise a fleet of cars and a helicopter in its fight against crime.

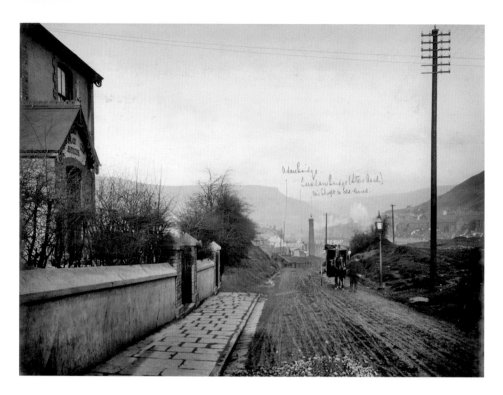

PENYGRAIG, Tylacelyn Road, c. 1900

A rough and ready road up the hill from Tonypandy shows a surface rutted by cartwheels and horses' hooves, this cart is hauling past the Penygraig Ruby Club. In the background is the Adare bridge. Today, a dusting of snow decorates the metalled carriageway. Penygraig RFC (left) is still here, but a petrol station and street lighting, and no colliery in the background, ring the changes.

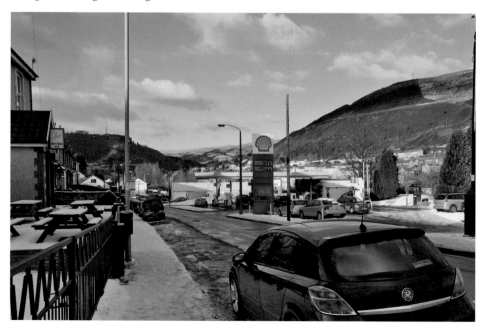

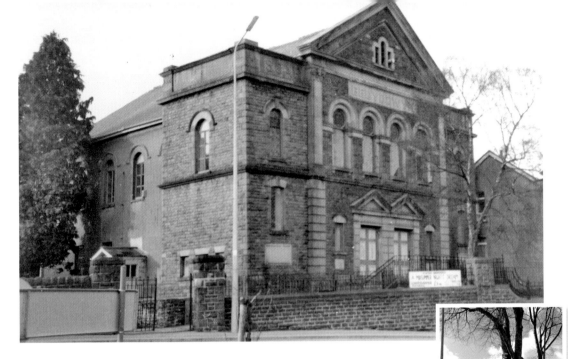

PENYGRAIG, Penygraig Road, *c.* 1994

Soar Welsh Baptist Chapel was built in 1832, and remodelled successively in 1858, 1875, and 1903, to include a square side tower. Closed in 1978, Soar now serves the community differently as a Youth Arts Centre. It presents a dramatically-altered side façade, with an elegant tinted glass atrial addition to full height. Distinctive double gates wrought in 'Penny Farthing' outline open past headstones of some graves of founding parishioners.

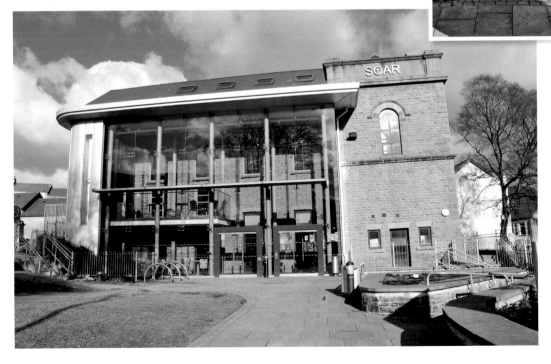

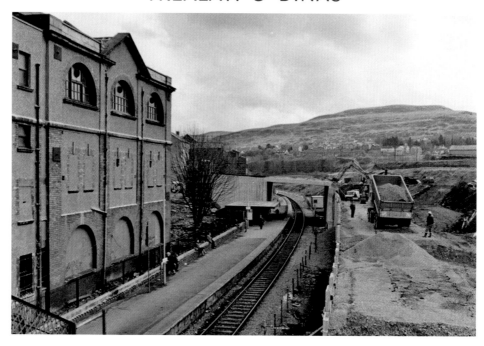

TREALAW, New Bypass Construction 1987

Looking easterly down-valley past Trealaw and Dinas. The now single railtrack and platform of Tonypandy station is seen abutting Judges Hall. Today we see this completed new highway has dramatically relieved traffic congestion, facilitating improved progress in the Fawr valley's middle section. Miles of clearway road now remove through traffic from the various villages. Roundabouts regulate traffic access to each side of the valley.

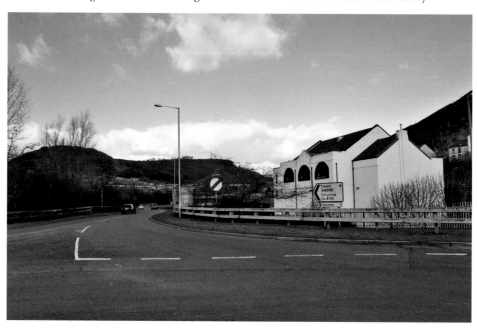

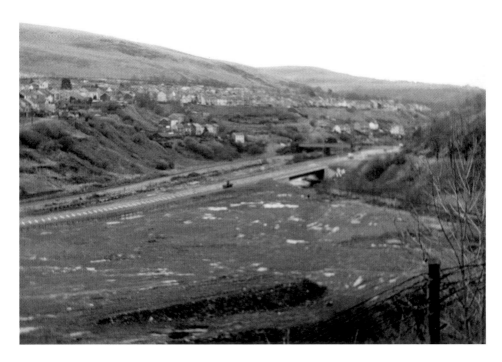

TREALAW, Ynys, 1989

'Today's production waste, tomorrow's spoil-heap'. Black waste mounds still marred this area for a quarter century after the contributing collieries closed and waste wagons left. The new Dinas bridge is seen ready to link new carriageway to bring in fresh enterprise. Twenty years on again and the Ynys area sports a new cul-de-sac road allowing access to a new hostelry, the Lord Tonypandy, a pub and carvery offering fine fayre on Mr. Speakers Way.

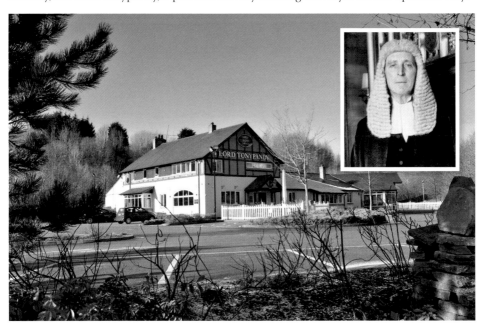

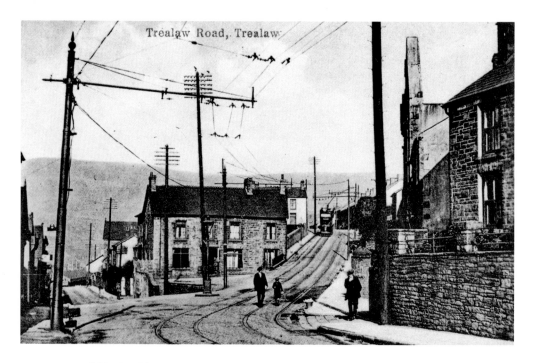

Trealaw Road, Trealaw

TREALAW, Miskin 'Fork', c. 1920

A tram heads down-valley to pass the Miskin Hotel sat betwixt the Trealaw and Tonypandy roads, overlooking a street-scene packed with poles, and the clutter of cables overhead. A man and boy stand centre street seemingly impervious to the electric vehicle's approach, despite a pavement. Today the Miskin still stands sentinel over the junction with an outlook now to modern traffic, a van standing in defiance of the roadside's yellow lines. The skyline is clearer, save for a distant hill-top mast.

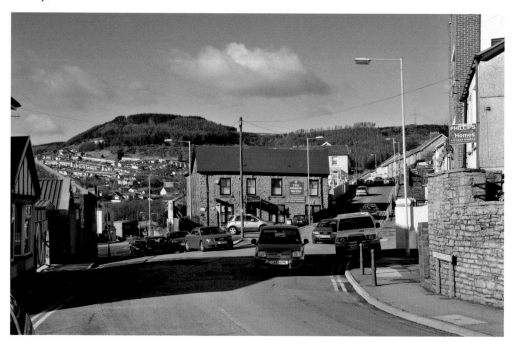

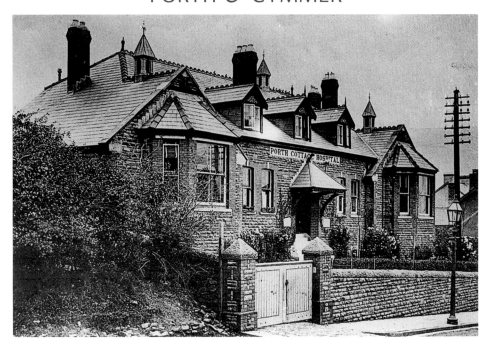

PORTH, Cemetery Road, *c.* 1915

Porth Cottage Hospital was established by coal-workers' contributions to answer demand for medical care from the exploding population of a previously pastoral locality. Its presence was also due to the efforts of pioneer coal-owner Walter Coffin, and local doctor, Henry Naunton Davies. Improvements to the fabric of the hospital continued and eventually it passed into NHS ownership. Superceded by newer, larger hospitals, the local authority redeveloped the complete site to provide Ty Porth care home.

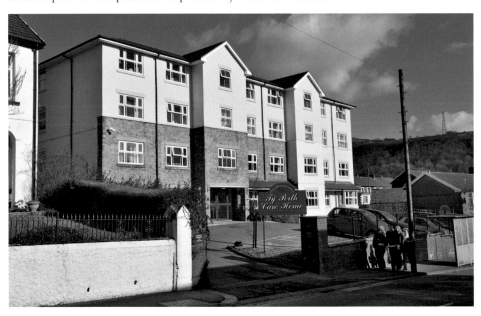

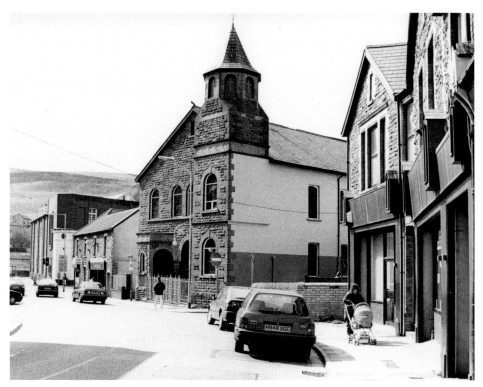

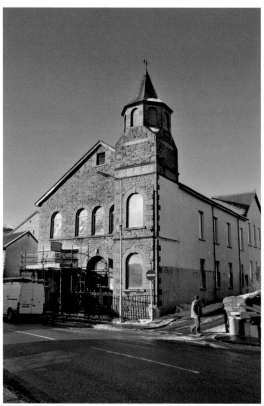

PORTH, Porth Street *c.* **1994**
The distinctive turreted elevations of the United Reform Church, formerly known as The English Congregational Church fronting Porth Street. Today, against the trend of religious closures, this fine building is pictured receiving care and repair. Its elegant arched windows are double-glazed to insulate its worshippers from the two lanes of traffic which now follow the infamous circular one-way system.

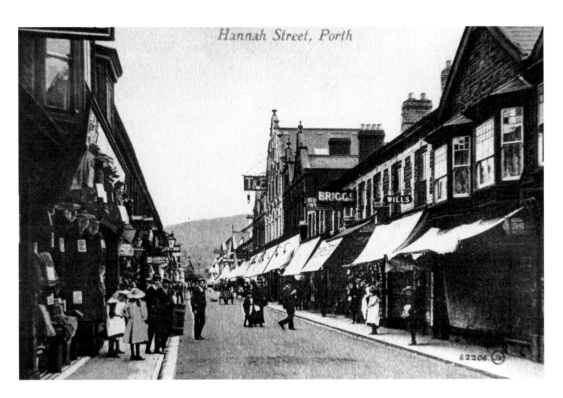

PORTH, Hannah Street, *c.* 1910
People throng the road and pavements of this bustling shopping street in a pre-traffic era, a flutter of shop canopies shading goods and browsing buyers on the sun-lit side. Today, shoppers wrapped warm against the wintry weather must adjust to parked cars limited by yellow lines and traffic on a one-way street. Drivers have a long way around now if no space is available!

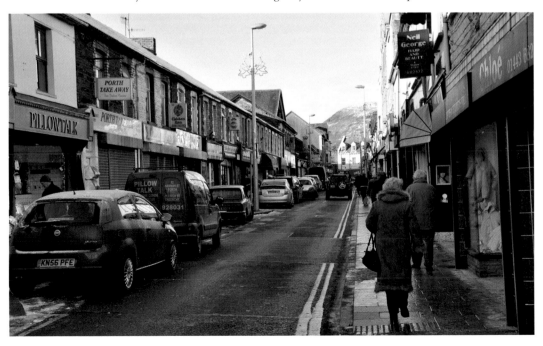

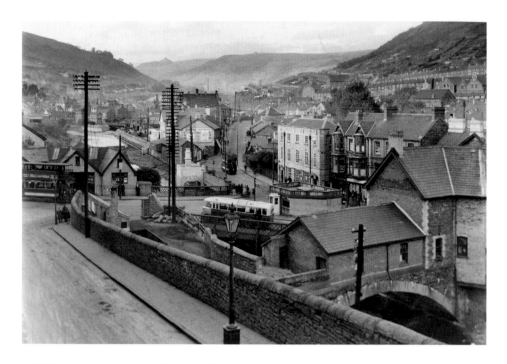

PORTH, the Square, from Cymmer Hill, *c.* 1933

Trams jostle for position with newer buses at this busy crossroads lying over the river. Dominated by the War Memorial, and overlooked by an imposing post office building, these surroundings are part of nearby, historical Porth Farm's original land. Significantly eclipsed by the new bypass bridge, the square today isn't one! It's now open; to meet the dictates of modern traffic, the river bridge increased to cope. No memorial stands central, whilst the post office is now a restaurant. 1950's schoolboy memories of visits to Porth Farm's 'Miss Jones' are recalled fondly.

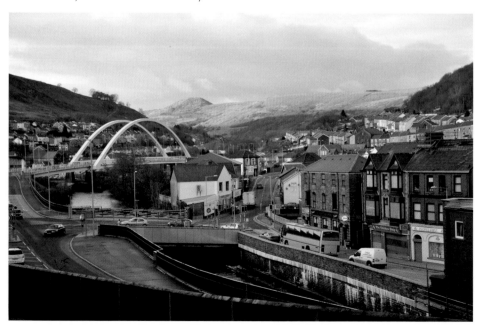

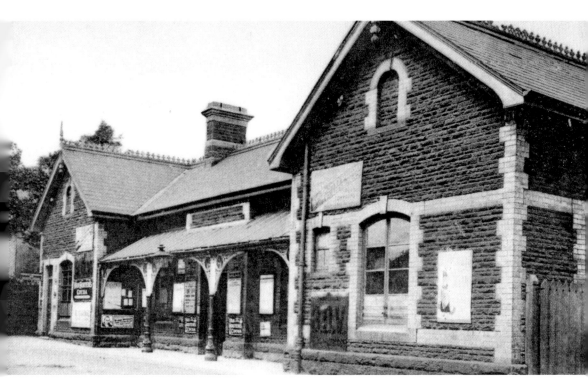

PORTH, Railway Station, c. 1900
Elegant in stone and brick, the station's
staff-room and warmed waiting areas
reflect the importance of local rail
services as the second largest local
employers – meeting the burgeoning
demand for coal transportation. Today,
the majestic age of steam, and bulk coal
haulage is long gone. Porth station now
offers passengers barely a brief shelter
to await trains of just a few diesel-
engined coaches which rarely reach the
extent of the old eight-coach platform.

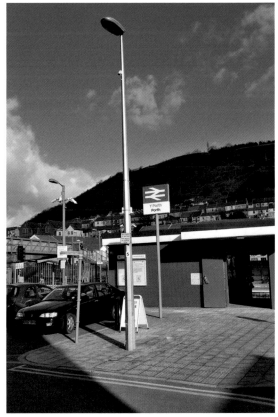

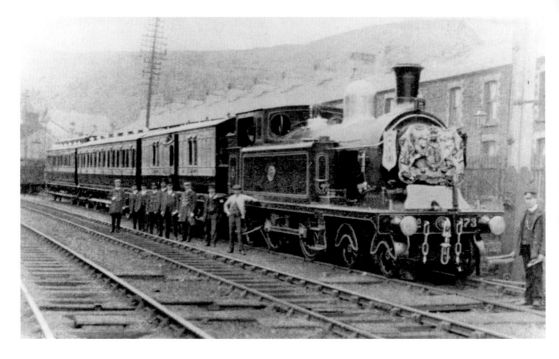

PORTH, a Special Train arrives, 1912
Porth station welcomes the royal train bringing King George V and Queen Mary on the first visit to the Rhondda to be made by a reigning monarch. Today's view down-track sees a reduced facility now designed to accommodate the more flexible modern stock of coach-style carriages, a far cry from Pullman cars of the steam era. Operation under modern diesel power benefits with cleaner windows for Taff Terrace close by!

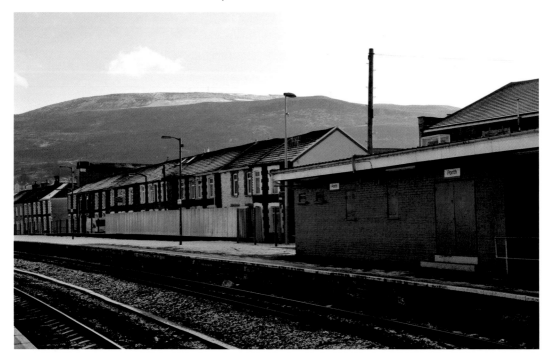

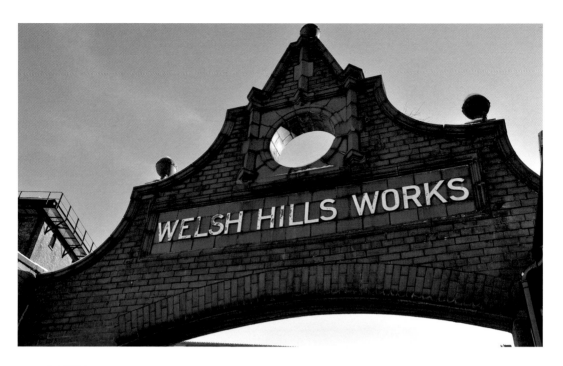

PORTH area, c. 1930s

Today, with Corona sold on to Cadbury-Schweppes and production re-located, the 'pop' of Welsh
Hills Works off Porth Street is modern and musical – achieving its second claim to fame as a TV
and recording studio. A handsome horse happily hauls one of Corona Pop's home delivery carts,
offering '4 Large Bottles in Case -1/-' (shilling = 5p of today's coinage) direct, no middleman! The
success of this range of carbonated fruit drinks spread across the country, to bring the first fame
for Porth's Pop Works.

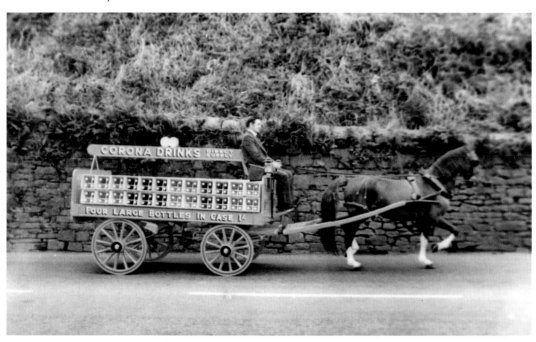

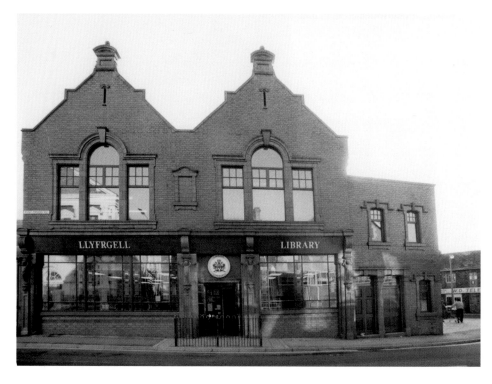

PORTH, Porth Street, c. 1991
Porth Branch Library's handsome red-bricked building after refurbishment, maintaining it's finely-decorated twin-gabled façade, offers wide windows to a railed curtilage. Since 2006 its classic façade has contrasted with that of the adjoining Porth Plaza's Training and Business Centre, comprising a stunning, contemporary design featuring front 'curtain wall' glazing to full height, adding new visual reward to the composite street-scene.

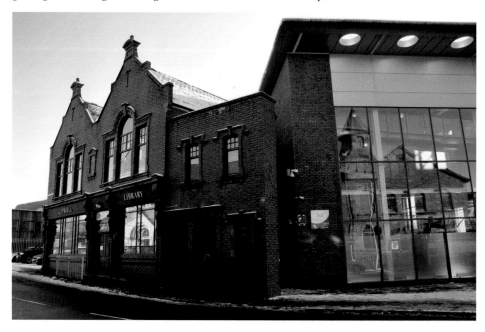

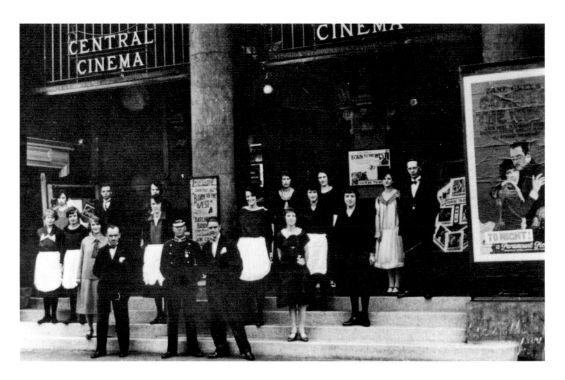

PORTH, corner Hannah Street, *c.* 1926

The tall pillared entrance of the popular Central Cinema with formally-attired Manager and welcoming staff. Film of the evening: a Zane Grey (American author and dentist) western starring Jack Holt. This cinema featured just a few 'love-seats' upstairs, hotly contested for by young buddies Alun and Alan in the late '50s, exhorted by fiancées Sue and Mair! Today clad in a blue exterior wash, the once imposing building is a shuttered shadow of its former grandiose, and has only bingo to entice local patrons.

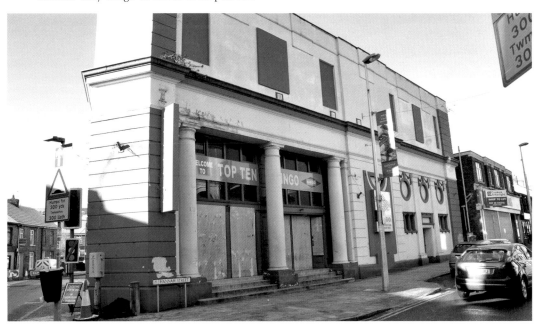

PORTH, Rheola Road, *c.* 2002

The popular, long-established Rheola public house offers traditional hospitality, ales and music. Its front entrance faces land occupied by corrugated metal-clad stores and workshop. Today a permanent 'rainbow' seems to curve benignly above the recently award-winning pub, for the new bypass bridge graces an altered skyline. On the ground opposite, the buildings have made way for a car park.

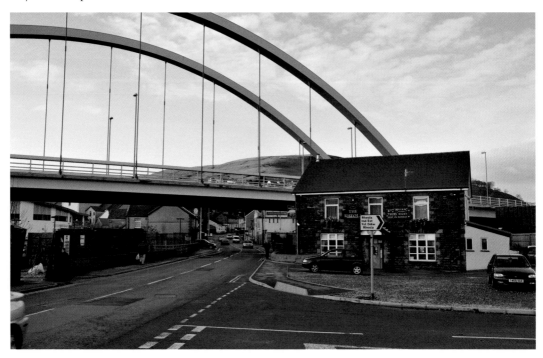

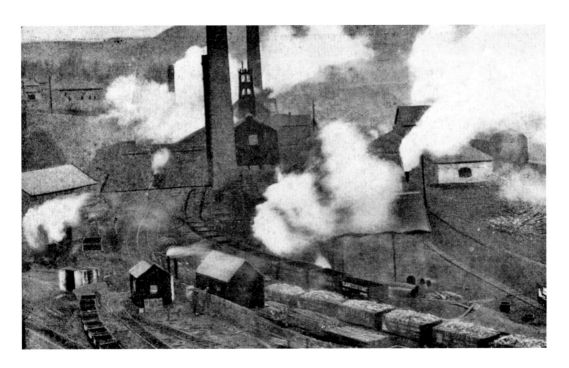

CYMMER COLLIERY, c. 1905

Started in 1847 by George Insole, the Old Cymmer shafts sank to over 1100 ft. The dangers of early mining manifested themselves in a horrendous 1856 explosion which took the lives of 114 men and boys. The combined Upper and New pits closed in 1940. Today we see on part of the colliery's re-landscaped tips, a large Morrison's supermarket occupying a plateau site – first operated as a grocery superstore by 'Pioneer'.

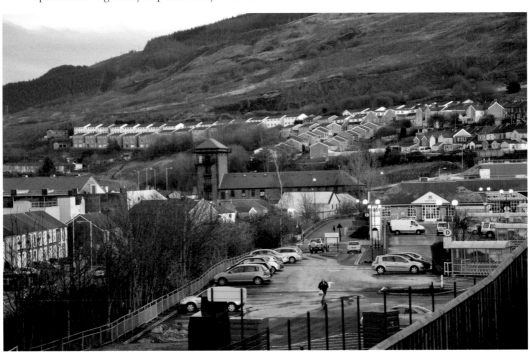

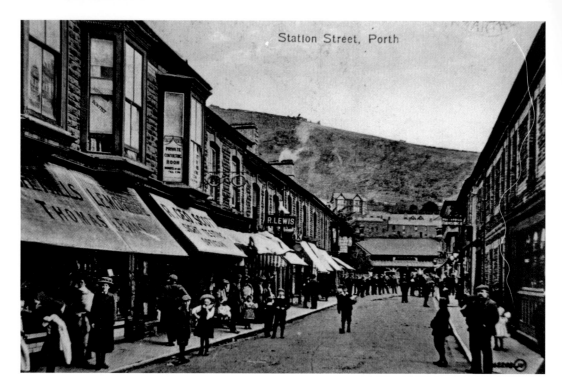

PORTH, Station Road, c. 1910

A bustling selection of shops to savour on the way to or from the busy station. Ground-floor trades gaily promote their names and wares on fascias, hanging signs and canopies, whilst lettered first-floor windows more quietly advertise the dental consulting rooms. No bustle in today's subdued commercial presence as shuttered shop-fronts testify to business closures – the sad loss of Bacchetta Brothers' iconic café just one. Car ownership too has changed the footfall to the station.

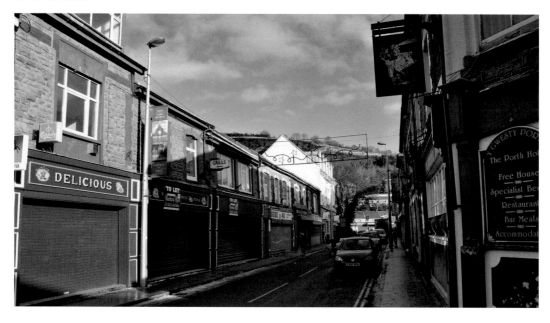

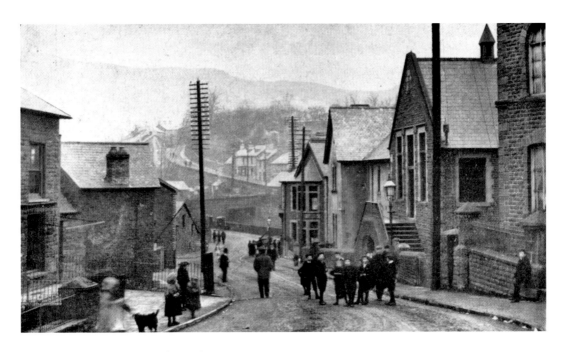

PORTH, Porth Street (upper), *c.* **1905**

Adults, dogs and children throng a street outside the chapels on the slope down to the old bridge. Looking towards Cymmer hill rising in the background, smoke is seen drifting across the valley, likely from the stacks of Cymmer colliery. Today, traffic lights release two lanes of traffic up the hill away from the 'square' and past the re-built police station. Cymmer hill seen beyond the new bridge is now accessed only from above by car, ending as a cul-de-sac.

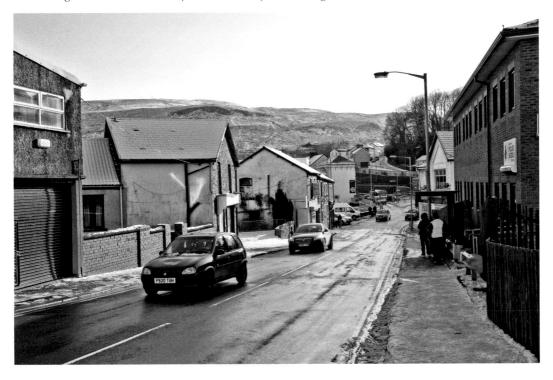

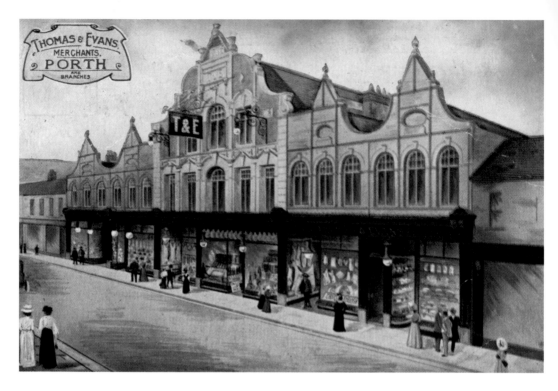

PORTH, Hannah Street, c. 1900

A coloured illustration of the Thomas & Evans store's period frontage, its grandiose gabled balustrading transforming an indifferent roof-line into a uniform façade. Today only the central gable remains. The elegant arched upper windows now countenance a variety of shops and service units. Favoured T. & E., like the pop works (and Elvis) have 'left the building', as too has the other iconic store, Woolworth's.

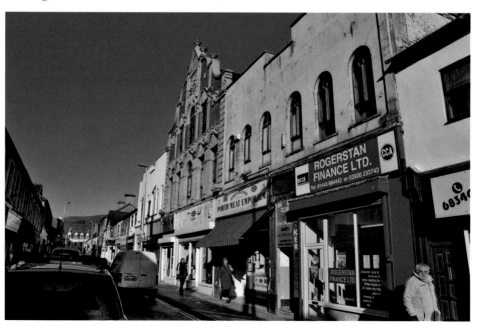

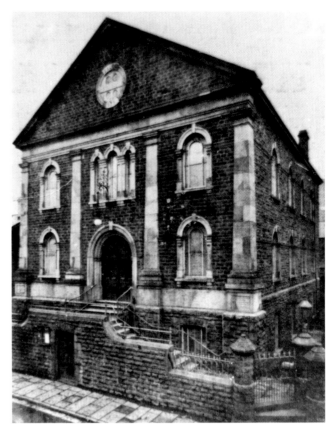

PORTH, Hannah Street, *c.* 1930
The towering presence of Salem Welsh Baptist Chapel, built *c.* 1900, also accommodating Sunday School in the vestry, seen below street level. Memories of this youth singing solo to its intimidatingly-full, echoing interior come to mind! Today, visitors are instead called to the fold of work, enterprise and training, at a Job Centre re-developed on the site of the gracious house of worship.

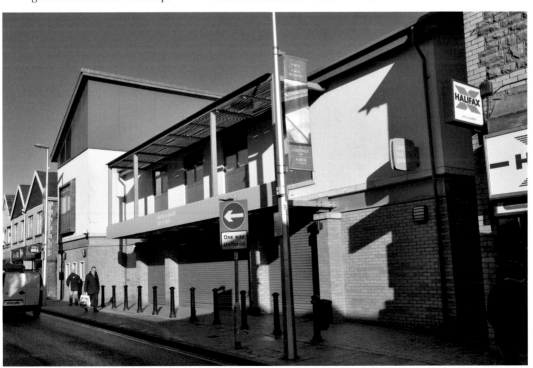

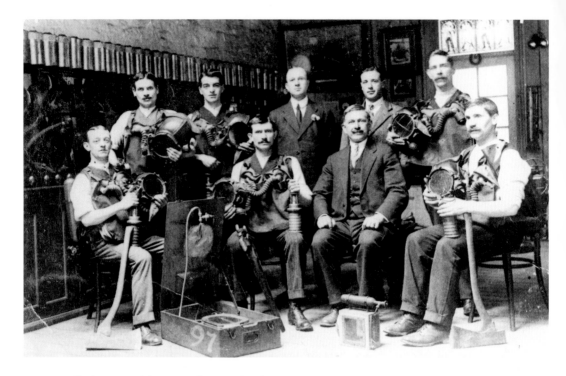

DINAS, off Dinas Road (now Appletree Close) *c.* 1910

The Mines Rescue Team was manned by valued volunteers who gave up time and risked their lives in the first formalised reactions to the dynamics and organisation required in accident response. Today although the major South Wales coalfield is closed, rescue facilities are still required and highly valued e.g. for drift-mine requirements, problems in old workings. Now the organisation is a full-time professional Specialised Training Establishment.

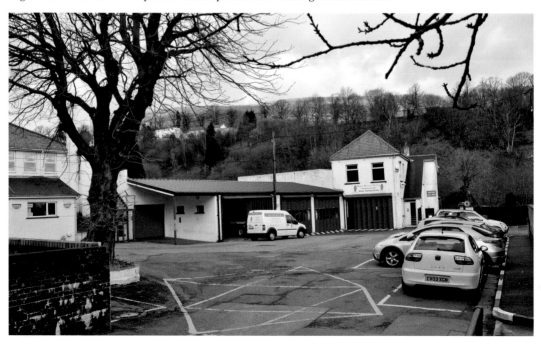

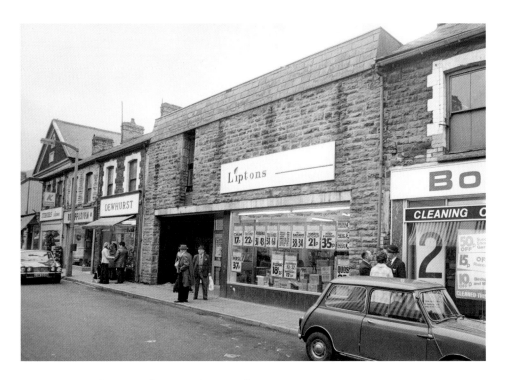

PORTH, Hannah Street, from Station Road, 1960s

Liptons' popular grocer's stores were widespread. The logo emphasised their tea-trading origins when customers' tea was blended, weighed, and packed individually. Flanking them, two popular names, Bolloms Dry Cleaning and Dewhursts butchers. Two iconic cars of the '60s are parked in view, the Jaguar XJ6 and the 'Mini'. Today, cars are parked nose to tail, but not to visit these three stores for they've each left.

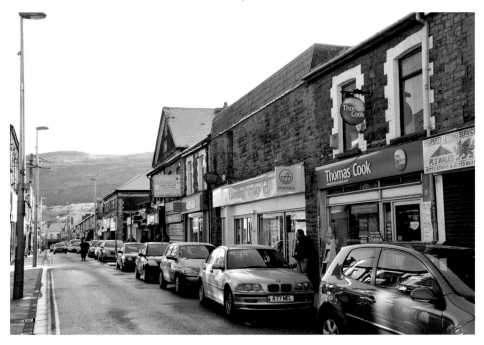

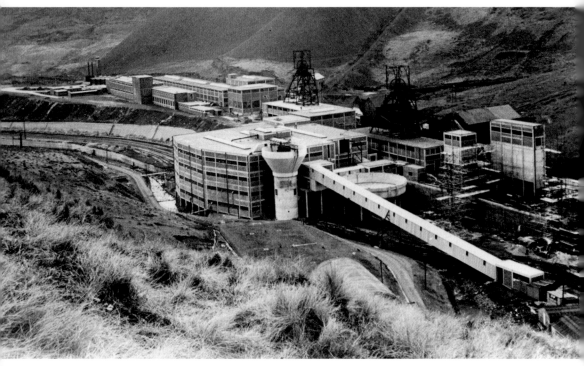

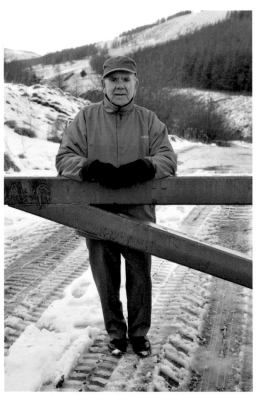

MAERDY Colliery, *c.* 1955
The 'Maerdy New Project' work, a massive £5m, scheme to reverse the decline since 1940 by redeveloping Maerdy 3 and 4 pits, to exploit '100 years' reserves'. Despite this massive investment, the saga started by Brecon man Mordecai Jones' purchase of the solitary 999-acre Maerdy Farm in 1873, was finally over. Maerdy Colliery, as the last deep mine in the Rhondda, closed December 1990. Today, aged seventy-six years, former miner Mr. Islwyn Jones looks over the reclaimed colliery land and remembers his first day at work as a fifteen-year-old 'first boy on the book' in 1949. His father Samuel also worked fifty-two years at Maerdy as a Winder.

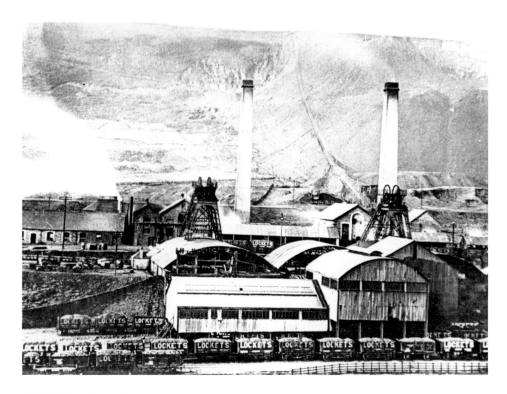

MAERDY Colliery, Pits 1 and 2, *c.* 1920
Steam coal mining, at this time under the operation of Lockets. This colliery was situated
1 mile north of Maerdy rail station first opened by the distinguished pioneer owner
Mordecai Jones, who connected it to Taff Vale's rails at Ferndale. Closed in 1940, it was over
fifty years before comprehensive reclamation of this area. Occupying part of the land today
is the fine new plant of the established local employer, Avon Engineered Rubber Co.

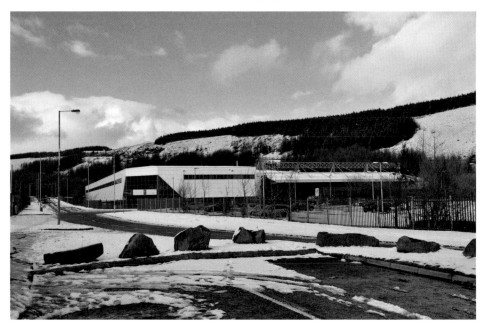

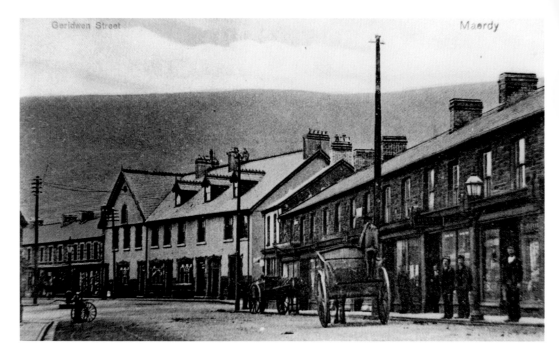

MAERDY Square, Ceridwen Street, *c.* 1905
Horse-drawn carts, and a hand-cart parked outside a corner shop share the wide street before trams, a central gas lamp lighting the square and the windows of the imposing frontage of the Maerdy Hotel. A fire gutted this popular large hotel in 1997. Today's square, replete with yellow-lined carriageway, shows a pub and wine bar 'The Hotel' on the end of the terrace, but a sad vacant site opens up the skyline where the mass of the 'Maerdy' once was. Better street lighting, though an over-worked telephone pole.

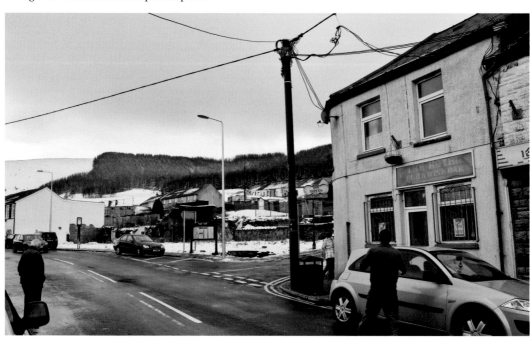

FERNDALE & BLAENLLECHAU

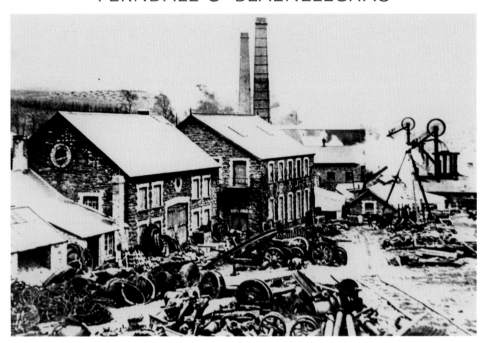

Ferndale Collieries 2 and 4, c. 1911
The David Davis & Sons colliery locally called 'The Ffaldau Pits' (in the folds) made their own wagons and drams in addition to repairing them. The Ffaldau men typically used the razor sharp 'white house hatchet' (Y bwyall ty gwyn) to cut the 'collar and arms' special splice for the Welsh notch pit-prop joints. Closed in 1930, today's reclaimed land advertises for new development pioneers, in the lee of the site of the modern Ferndale Community School, and its aspiring pupils.

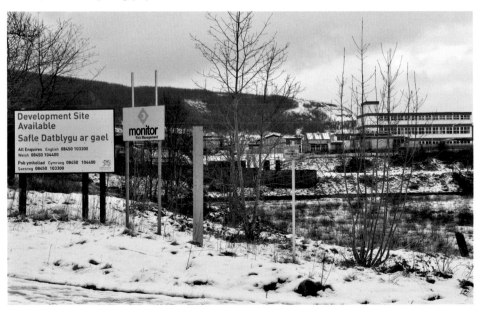

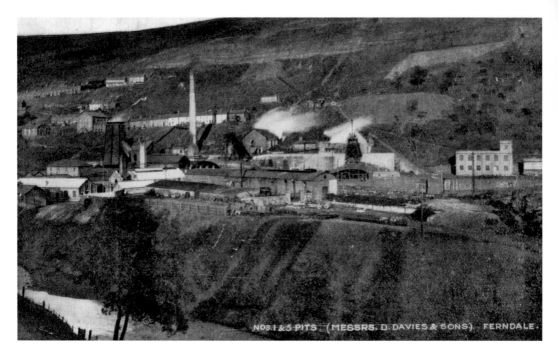

NOS.I & 5 PITS. (MESSRS. D. DAVIES & SONS). FERNDALE.

FERNDALE 'Nos. 1 and 5' pits, *c.* 1915

These two pits were sunk by D. Davies & Sons in 1912 – they followed that firm's first two, No.2 and No.4. The first pits, also known as the 'Ffaldau' sadly suffered two terrible disasters, in 1867, and 1869 claiming a total of 231 miners' lives. Beneath a local 1988 memorial to the lost men; a time capsule is buried with a scroll of all their names. Today's jobs are on the surface of the reclaimed land, a development of smaller factory and service units.

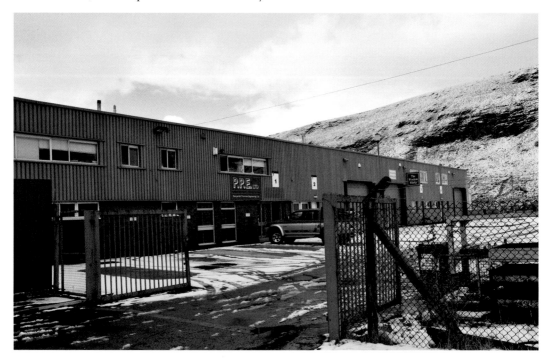

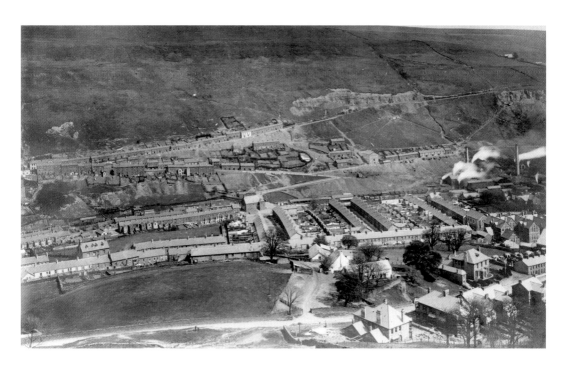

FERNDALE & BLAENLLECHAU, General view *c.* 1900
In the foreground the historic longhouse of Rhondda Fechan Farm with its land extending to the
rear, and set above the main village diagonally across the valley from Darren Parc. In the new
image we see the houses of 'Rhondda Fechan Farm' modern development, now occupying the
rear field.

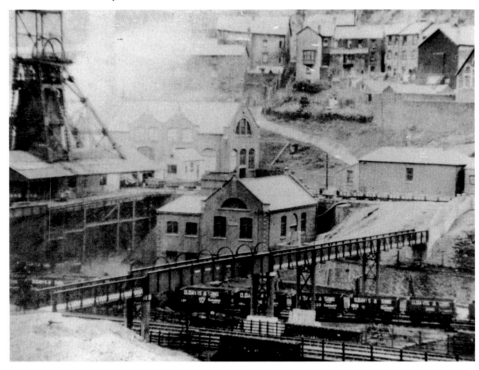

TYLORSTOWN Colliery (Pendyrus), c. 1928

In 1872, mineral rights to Pendyrus lands were bought by Alfred Tylor, hence the village's name. Uniquely a bridge connected the pits' surface directly to Stanleytown. The first steam coal was not won though until 1876 (from Pits 6 & 7), railed to Cardiff 1877. Coaling ceased in 1936, and '6 & 7', along with '8 & 9' for decades were retained for pumping/ventilation duties, and then closed by the NCB in 1960. Today's bridge over the Afon Rhondda Fach links the shaded central village to the original terraced homes on the sunny slopes of its elevated neighbour.

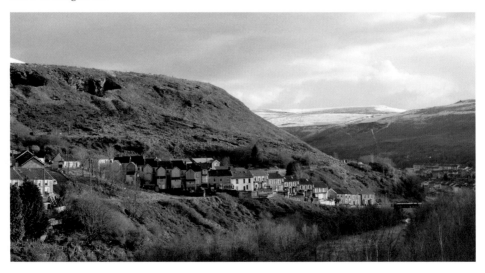

PENRHYS, Penrhys Uchaf, *c.* 1960

Sitting on the exposed summit of Mynydd Penrhys, Penrhys Uchaf farm's bovine stock could have contributed the cowpox antidote to the feared smallpox virus, for which the neighbouring isolation hospital was to anticipate. The fear became a reality in 1960 with the smallpox outbreak. Today, both buildings have been demolished. Instead colour washed houses cling to the summit, close to the clouds.

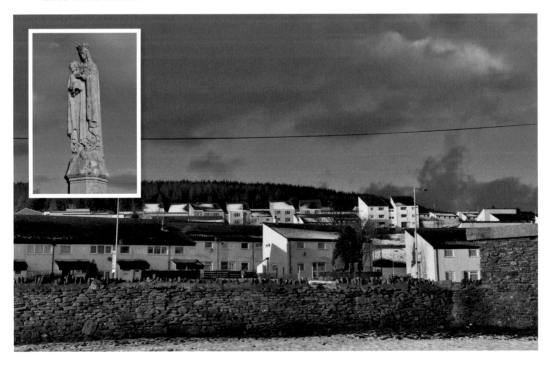

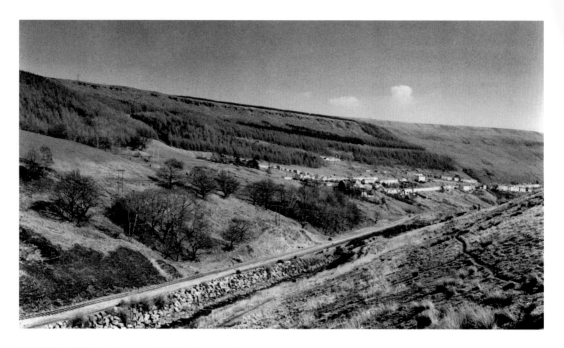

BLAENLLECHAU, slopes of Cefn Gwyngul *c.* 1910

The slopes of this village featured the sole commercially-worked level mine (as opposed to sunk shaft) in the Rhondda Valleys where the men of David Davis & Sons utilised the 'pillar and stall' method of driving an opening into the coal-bearing seam with cross-headings cut at right angle intervals thus creating access bays. Today those same slopes above the village show new forestation on and below the limestone crest.

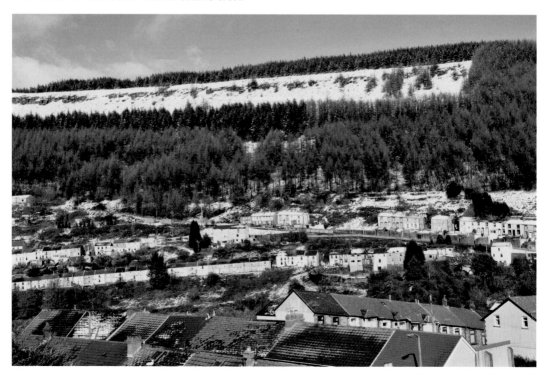

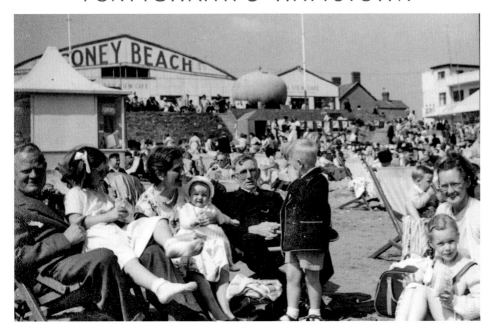

SUNDAY SEASIDE TRIPS from both Valleys *c.* 1950

Every summer, the highlight for us children was a Sunday School or Workingmen's Club trip to Barry Island or Porthcawl's Coney Beach. These trips were a paid-for event in the valley's calendar. Lines of buses would carry hundreds of excited children all eager to be the first to shout 'I can see the sea'! Welsh poet and author Gwyn Thomas's comment on these trips was "The Sunday School trip to the sea. One day a year, one magic glimpse of the sea. Baptists to Barry, Congregationalists to Porthcawl, Methodists to Penarth...and Buddhists to Aberavon Sands." Today such trips have all but gone and the seaside resorts struggle to survive or look forward to regeneration.

YNYSHIR & TYNEWYDD

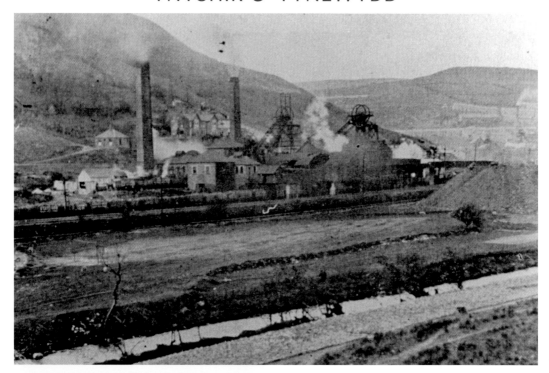

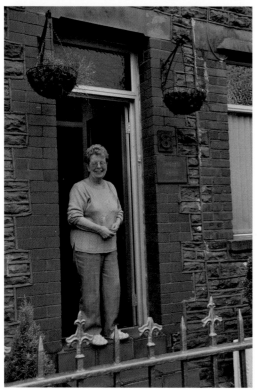

YNYSHIR, The Standard Colliery *c.* 1901
A productive pit sunk by James 'Siamps'
Thomas in 1876, a well regarded man
reputed to have started in the coal
industry as a 'door boy' at the age of six.
He progressed through various positions
to colliery manager, and lived close to the
Standard in a house he built called Bryn
Awel, which is now a care home for the
elderly. Ynyshir resident Mrs Gardner of
Myrddin House, Station Road whose late
husband was a miner receives delivery of
anthracite fuel for her central heating.

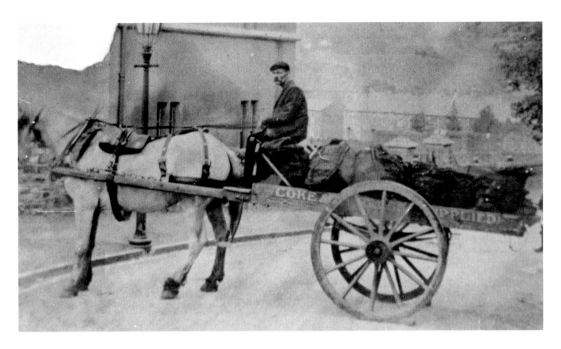

YNYSHIR, Coal doorstep delivery *c.* 1908
The horse-drawn cart of Walter Bending was a familiar sight on the valleys' streets selling bagged coal and coke door to door. Surprisingly continuing this delivery tradition, we see John lifting a 50kg bag of anthracite beans for the central heating boiler of mining widow Mrs Gardner. No longer sourced from the Rhondda this fuel comes from Onllwyn Open Cast Mine, in the Neath valley.

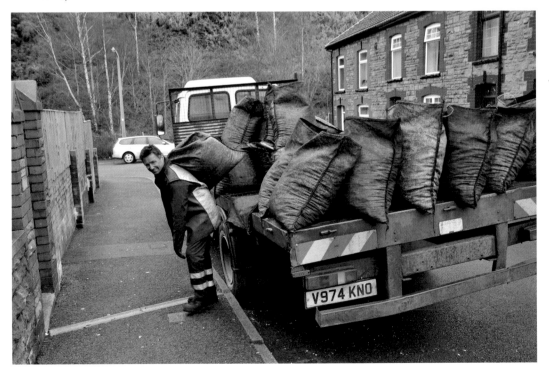

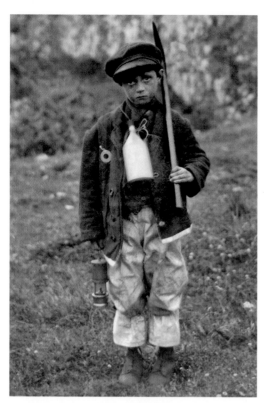

The Miners' lamp

A typical young mine worker photographed in 1920 whose small frame had to carry all of his equipment including lamp, water flask and mandrel. By this time the industry enforced a minimum age of thirteen years for previously boys as young as six years would be working long days underground. The safety lamp of author's grandfather, Mr. William Thomas is an example of the invention by Sir Humphry Davy in 1815 which provided essential safety for the coal miner.

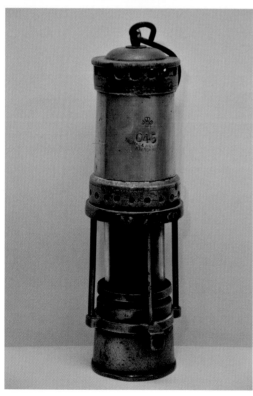

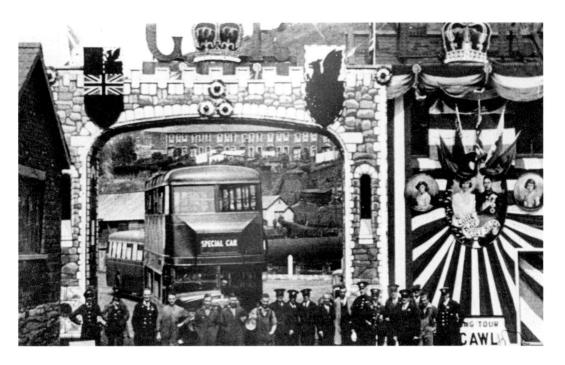

TYNEWYDD, Rhondda Bus Depot 12 May, 1937
Staff stand ain front of a high, decorative archway built across the depot's entrance to colourfully celebrate the coronation of King George VI and Queen Elizabeth, which includes pictures of the two young princesses. An approaching double-decker bus carries 'Special Car' in its front panel. No longer the home of the iconic red municipal buses, today many new franchised companies utilise the facilities here, single-deckers predominating.

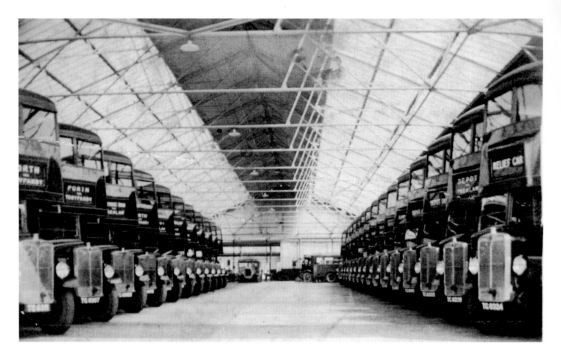

TYNEWYDD SQUARE, Porth c. 1950
The full fleet of Rhondda UDC double-deckers garaged nose out ready to carry a new day's passengers through both valleys (except the single-decker routes over Penrhys, and the long climb to Blaenclydach). Today's two gleaming red Leyland Atlantean double deckers run the school routes and are examples of these firm favourites from the municipal fleet pre-privatisation.

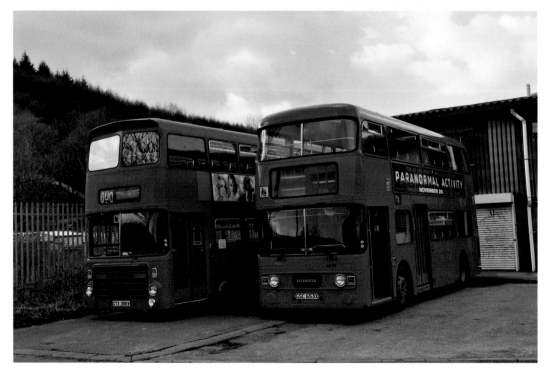

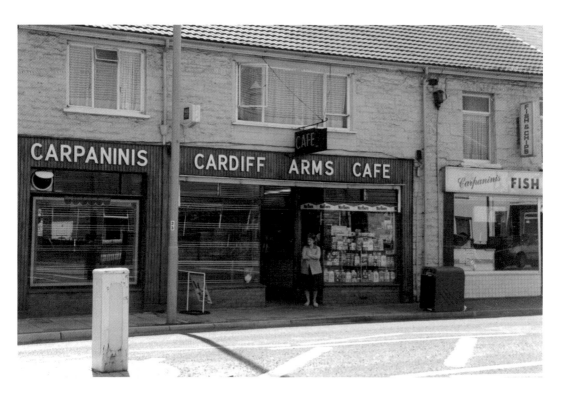

'The Italian influence' – Better coffee, better ice-cream!
Remember those wonderful, warm creamy coffees and steamed-hot pies after the pictures? Or the first juke-boxes of the fabulous fifties? Mr. & Mrs. Ernesto Carpanini opened their café in the 1940s. Mrs. Carpanini, one of two sisters who married two brothers, is pictured alone some forty years later. Today we see their son and daughter continuing the business at the two premises, where a warm welcome is still assured!

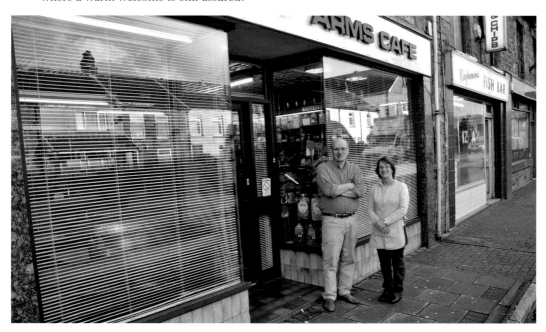

This book is dedicated to the memory of Stanley and Louisa Seward.

*Our thanks are due to the Rhondda Cynon Taff Library Service for
the use of photographs from their Digital Archive Collection.*

These and many other photographs can be seen by
visiting their website at www.rhondda-cynon-taff.gov/photos.